Photographs symbolize
the beauty that resides in all things,
the spirit that inhabits all objects,
the temporal nature of life experiences.

DOUGLAS BEASLEY

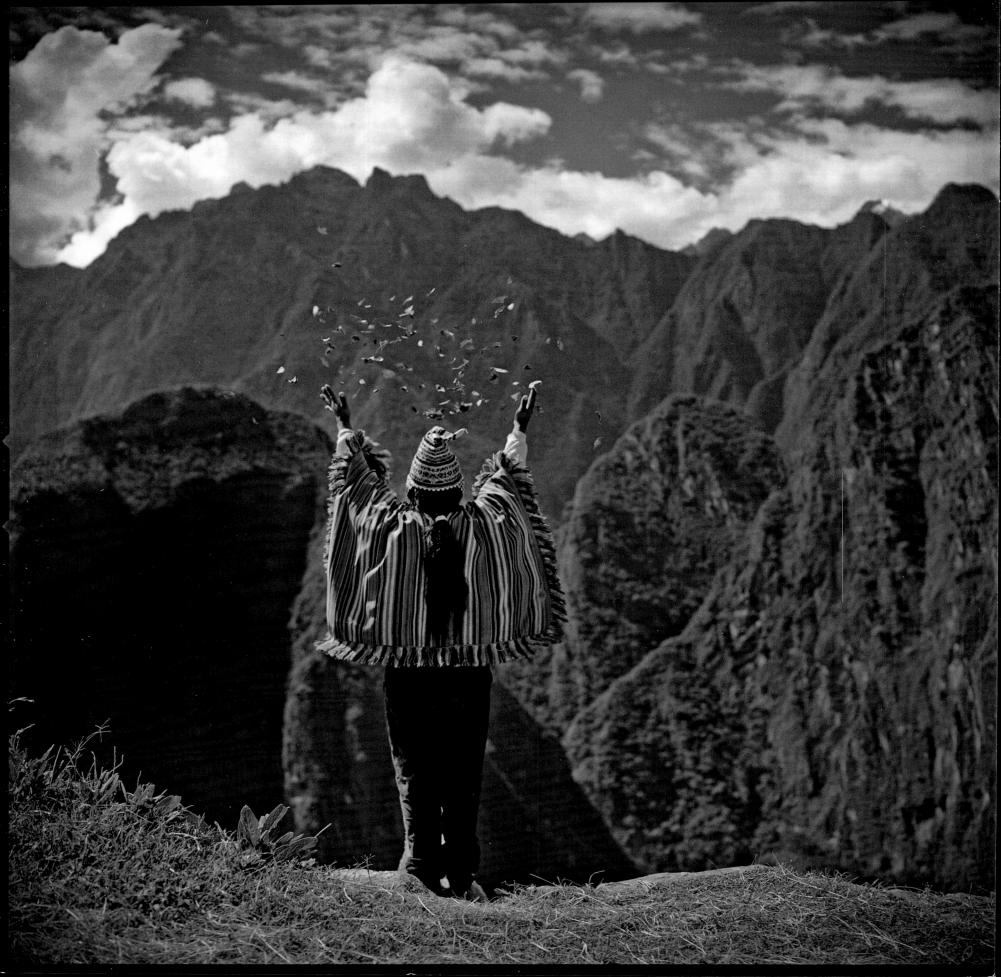

Earth MEETS Spirit

A Photographic Journey Through the Sacred Landscape

FORWARD BY WINONA LADUKE

GEORGE SLADE INTRODUCTION

PHOTOGRAPHY | DOUGLAS BEASLEY

5 CONTINENTS

Graphic Design
Krista Matison

Color Management
Rick Haring

Library of Congress Cataloging-in-publication data
Beasley, Douglas
Douglas Beasley Photography

© Copyright 2011 by 5 Continents Editions for the present edition

ISBN 5 CONTINENTS EDITIONS 978-88-7439-600-9

Editorial Coordination
Laura Maggioni

Production Manager
Enzo Porcino

5 Continents Editions
Piazza Caiazzo, 1
20124 Milan, Italy
www.fivecontinentseditions.com

Distributed in the United States and Canada by Harry N. Abrams, Inc., New York.
Distributed outside the United States and Canada,
by Abrams & Chronicle Books Ltd UK, London

Printed in Italy by Grafiche Flaminia, Foligno (PG) in August 2011

There is only one journey: going inside yourself.

RAINER MARIA RILKE

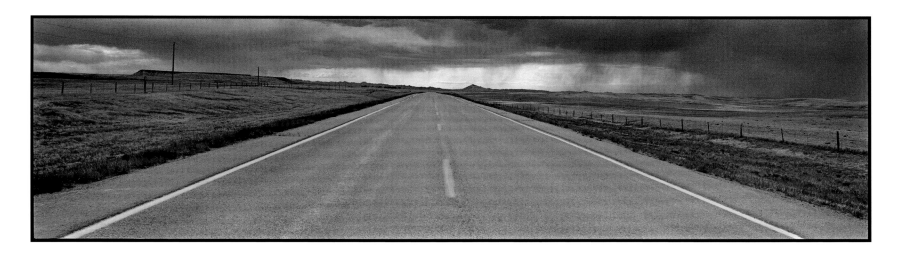

HIGHWAY AND RAINSTORM

BADLANDS, SOUTH DAKOTA

AKAWE – IN THE BEGINNING

In that space between darkness and dawn, *Bii-daabin*, we sometimes awake to ourselves. Absent the trappings of polyester, petroleum by-products, combustion engines, digital time and the sound of a clock, we return to be those people, those spiritual beings that we are. This book is about that place and how the land remembers us – that place is in our souls. This book is about how far we have come from that place and how we can take a step back.

Anishinaabe Akiing is the name for the territory the Anishinaabeg or Ojibwe have come to live in – formed by rivers undulating between lakes, small to the largest on the continent – not states, provinces and borders formed by Empire. *Omaa Akiing*, or "here on this land," the Anishinaabeg know that Anishinaabe Akiing does not mean private property, or the land of the Anishinaabeg. It means the land to which the people belong. That is a spiritual

concept that reaffirms relationship. The prayers and offerings depicted in Beasley's book are the reaffirmation of this relationship to place.

This book is a window into a time when we can place ourselves in a spiritual realm, to look at where we are, and where we have come from. The photographs here tell the stories of beauty; of hurt; of damage; and yet – as we know in our souls and in our minds – of our own forgiveness. This is to say, we are able to recover our relationship to place, or earn a relationship, by being prayerful (as Charmaine White Face notes in the book), and by our actions. To be those people – those people who can stop a river from being reversed, a mine from leveling a sacred mountain and poisoning a river – is the greatest of spiritual opportunities to be *pono*, or "righteous."

We can be those people who recover names. The naming and claiming of this land as Empire necessitated the names of

Harney Peak, Mt. McKinley, Mt. McKay, and Devil's Tower. The names of the Heart of Everything that is – Mt. Denali, The Mountain where the Thunder Beings Rest in their migration from West to East, or the Grey Horned Butte – are close, are within our grasp and our memories. This is the beauty of recovering from Empire, the beauty of recovering relationship. For just as we need our Mother, she needs us to be those courageous and pono peoples.

In this greatest of times, we draw on the beauty of these photographs, their connection to land, place and spirit, and we recover our place in this world. In that process, perhaps we become patriots – not to a flag, but to a land.

WINONA LADUKE

Native American Activist, White Earth Reservation

CHANGING STATES

Douglas Beasley's photographs speak eloquently of membranes. They elicit notions of transfiguration, of change from one substance into another. His photographs are profoundly conscious of life in flux. He records impossible moments when liquids become solids, solids lose their structure, and vapors and mist gain palpable presence.

I recall once seeing a photographic emulsion separated from its deteriorating backing, literally floated off its support in a liquid bath in order to be re-adhered to a more stable substrate; that a photograph's essence, its very spirit, could drift like a veil in water is of a piece with Doug's photographs.

I also recall when my daughter was born, hearing the midwife describing a "buttery" cervix, a tissue-thin barrier between the almost-newborn and the world she was about to enter. That barrier effaced, moved itself aside and opened like an aperture to usher the new life into the light.

Beasley's photographs seem most centered when they address this meeting place of states, a liminal site in which change occurs. In addition to addressing the linear nature of solid-liquid-gas, his images successfully describe transformations that are less measurable, though no less tangible. The wonder, and a unique aspect of Beasley's accomplishment, is that the invisible, what we might have thought of as unpicturable, appears in his photographs.

It is no accident that Douglas Beasley is a deeply spiritual person. Or that his photographs describe these improbable meeting grounds with such clarity of intent. There is, in all likelihood, a circular, heightening relationship between the man and the land that the photographs track with increasing awareness and efficiency. Early on, Beasley experimented with holding up objects to indicate his sense of self-implication in the places he was describing. Later works dispense with the hands-in approach and affirm that the works are sufficiently persuasive with eyes-in; camera and film can, it turns out, see what is felt or intuited, and can by effortless extension symbolize the photographer's sense of attachment.

Sometimes the photographic material itself imputes its own mysteries and delights. The Polaroid film Doug used for a long time, film which created both a positive, single print and a negative from which prints on other papers could be made, had its own unique set of marks around its edges and at either end of the "pull-apart" package. Indeed, the introduction of focused,

measured light into these sandwiched materials was another space of transformative exchange in which light becomes silver becomes shades on another paper. Like fingerprints, no two Polaroid negatives bear the same configuration of separation traces; the images also bear other inflections, even scars of incomplete development. Again, the material contributes to the inchoate yet highly evocative description that Beasley brings to his work.

Just as photographs serve as conduits for light, the subject matter of Doug's images often record efforts at mediating between one state and another. Some efforts, like sacred circles and other spiritual linkages to natural spaces, are ancient and time-honored means of harvesting from the land. Other man-made efforts, done in the name of energy generation (the good), suburban development (the bad), and xenophobic, genocidal nationalism

(the ugly), also play out in these works. In all, Beasley demonstrates a consistent interest in transformation, in passing through one state to another.

Words are hollow, ineffective tools for properly capturing the energy of Beasley's photographs. At best we can describe what is seen and try to summarize what is implied, which ultimately speaks of gestures, of nods and acknowledgments. These photographs are full of life and change. Witness, liquid life in flowing rivers; blood flowing, or not; wind breathes and blows throughout these pictorial and real spaces. Nature respires, sap flows, birds take wing and expire. Choices we "modern" humans make seem so garish against the hard, clear beauty of the land. Beasley's photographs are mindful exchanges with the visual; they engage honestly and

without judgment, though there is no shortage of emotion lying latent in them.

The picture plane is the membrane, the point of intersection between earth and spirit. For Beasley, the physical and metaphysical are yin and yang; his photographs serve as recognition of difference and as an embrace of mutual dependence.

GEORGE SLADE
Writer and Photography Historian

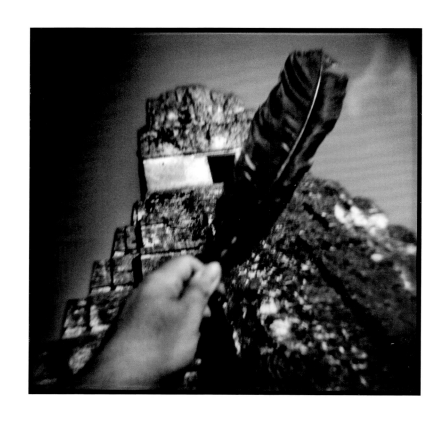

SELF-PORTRAIT WITH FEATHER, TEMPLE OF THE JAGUAR

TIKAL, GUATEMALA

MADE WITH PLASTIC TOY CAMERA

No matter what role we are in
– photographer, beholder, critic –
inducing silence for seeing in ourselves,
we are given to see from a sacred place.
From that place the sacredness of everything may be seen.

MINOR WHITE

When I learned to interpret and start to transfer what I was feeling into my photographs I awoke into the mystery of art. Photos could become poems or prayers. They could become a vehicle of mystical interpretation. They could convey visually moods and emotions that I could not express in words.

When I started photographing sacred places around the world I found myself trying to convey the grandeur of these amazing, mysterious places. But it was the places themselves, not my photographs, that were grand and that held the mystery. When I realized I couldn't make a print big enough to show what these sacred places were like I realized I was headed in the wrong direction. I decided to make the prints very small and intimate to try to preserve some of the mystery held by these special places.

The image of my hand holding a feather in front of Tikal (left), made with a plastic toy camera, is my attempt to relate personally with a place so monumental that it took thousands of slaves perhaps hundreds of years to build. It isn't necessarily a great photograph but it set in motion a string of questions that I needed to ask of myself: How many lives were sacrificed for someone else's vision of 'sacred'? What makes a landscape sacred? Why is one place sacred and another not? Isn't everywhere sacred? Are some places more sacred than others? What is my motivation in photographing these places? Is it wrong to photograph what is sacred to a culture or people other than your own?

I found myself moving from the grand gestures made by masses of slaves in service to an elite vision towards more small and intimate personal gestures of sacred. I was moving away from using other people's expressions of sacredness to using metaphor to find my own.

Like my own journey through religion towards spirituality, photography has become the inward journey to be more in touch with my inner self, more authentic in my own vision and more elemental in my approach.

DOUGLAS BEASLEY

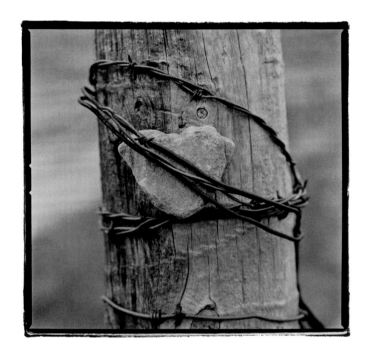

HEART ROCK MEMORIAL
WOUNDED KNEE, SOUTH DAKOTA

What is the notion of 'sacred' and why is this important? Can honoring what is sacred to others lead us to our own notion of the sacred? Can the sacred enhance or deepen our spiritual awareness?

The photographs from this series, funded by a McKnight Foundation Photography Fellowship, were made in the Badlands and Black Hills of South Dakota, areas long considered sacred by the Lakota (Sioux) Indians and now under imminent threat of development by mining interests, population expansion and tourism. Where these places are is not as important as what they represent and elicit, a deep respect for and an honoring of the earth as nurturing and sustaining of all life. If native people lose this land and their connection to it, we all lose. These photographs attempt not to document these sites, but to visually reveal a sense of sacred space in hopes of sharing with the viewer why this landscape must be preserved for the spiritual enrichment of all people for generations to come.

My photography is about exploring the spirit of people and places. In recent years I have become involved in numerous personal photographic projects within both the Native American community and within my own Asian American heritage. After study of both Native American culture and Eastern religious practice I have found many similarities and parallels such as respect for ancestors and the belief that objects possess a spirit, even rocks and trees. In my photographs I try to convey spirit in all things, large and small; I find this approach recognized and celebrated in both Japanese and Native American cultures.

Perhaps recognizing what is considered sacred by other cultures and religions can help us discover a misplaced sense of what is sacred lying deep within our own lives.

>

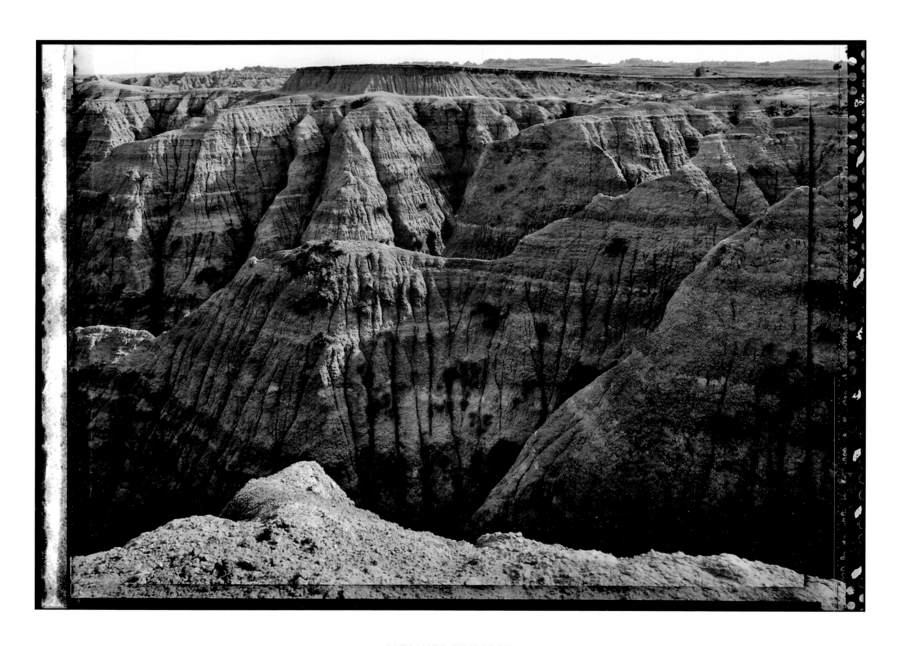

BADLANDS OVERLOOK

BADLANDS NATIONAL PARK, SOUTH DAKOTA

FROM THE SERIES

Sacred Sites of the Lakota

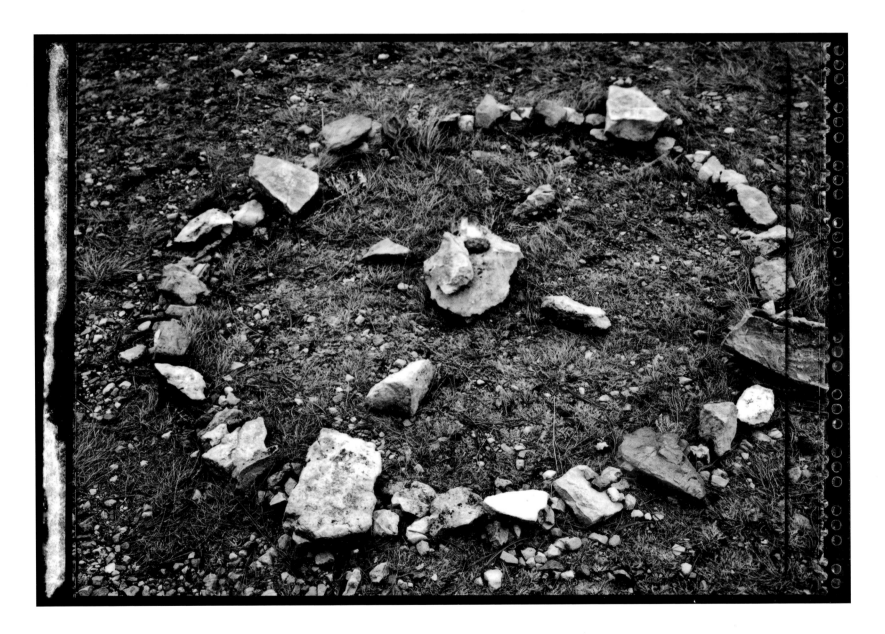

MEDICINE WHEEL

BEAR BUTTE, SOUTH DAKOTA

FROM THE SERIES

Sacred Sites of the Lakota

I hope I will be quiet enough to hear what the subject is saying.

PAUL CAPONIGRO

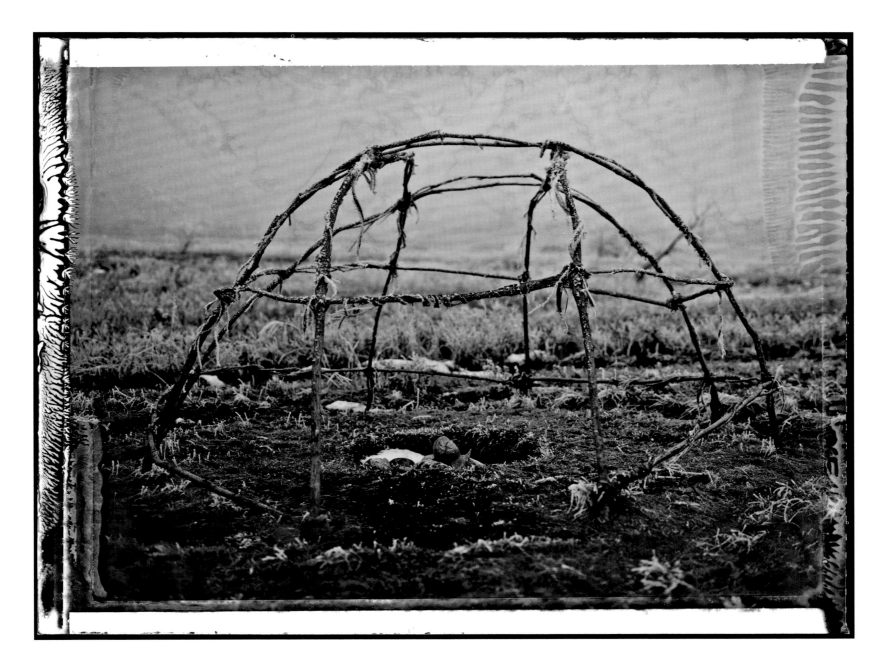

SWEATLODGE AT SACRED PIPESTONE QUARRIES

PIPESTONE, MINNESOTA

FROM THE SERIES

Sacred Sites of the Lakota

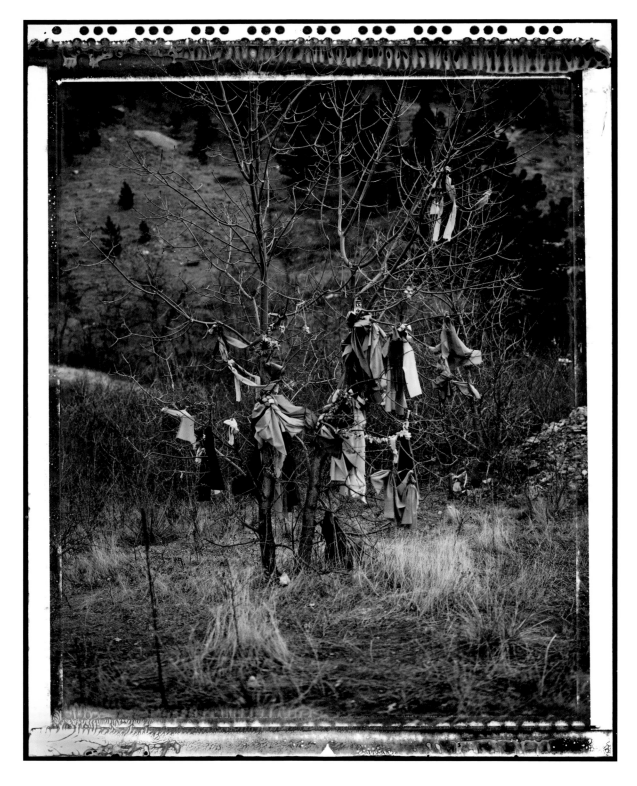

PRAYER FLAGS IN TREE

BEAR BUTTE, SOUTH DAKOTA

FROM THE SERIES *Sacred Sites of the Lakota*

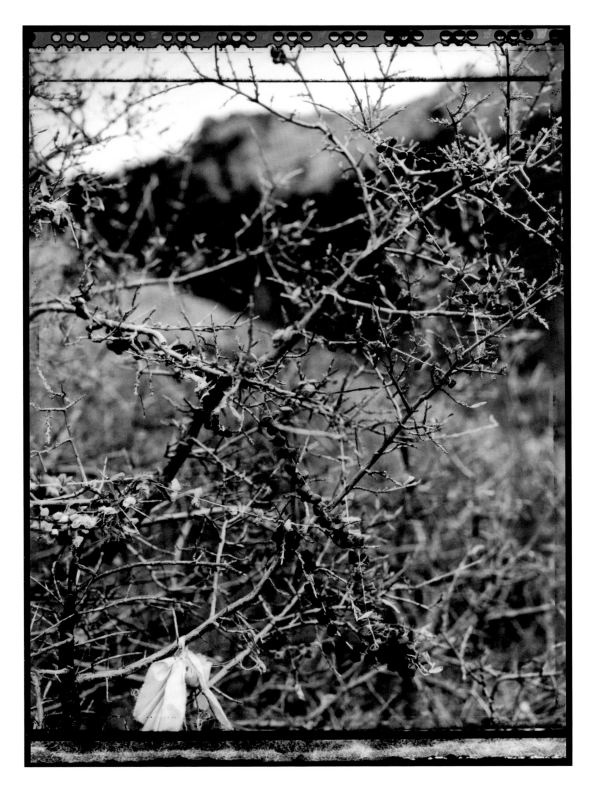

TOBACCO TIE PRAYERS IN BUSHES

BEAR BUTTE, SOUTH DAKOTA

FROM THE SERIES *Sacred Sites of the Lakota*

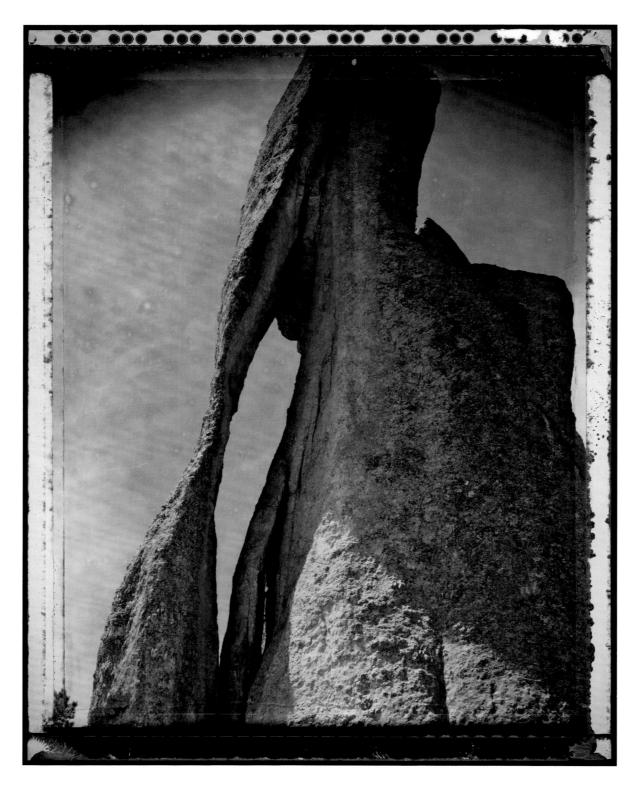

NEEDLES

BLACK HILLS, SOUTH DAKOTA

FROM THE SERIES *Sacred Sites of the Lakota*

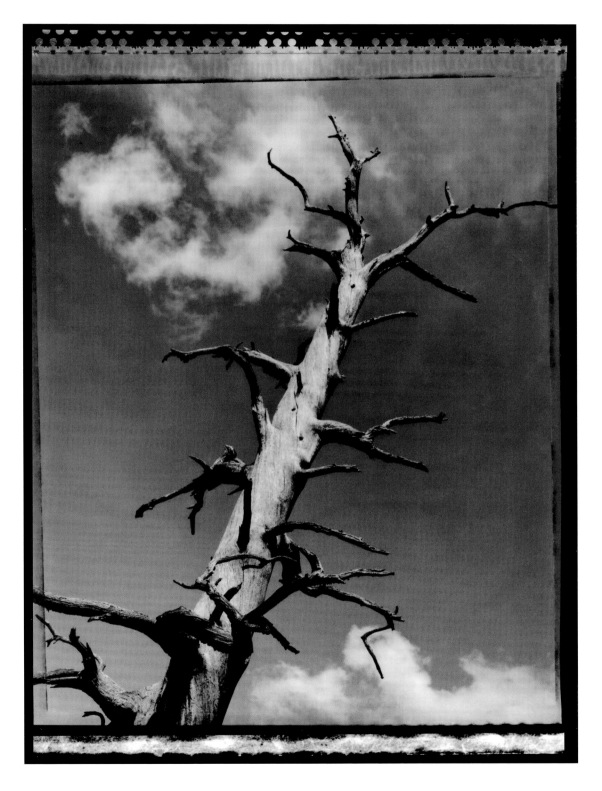

ANCIENT TREE

BLACK HILLS, SOUTH DAKOTA

FROM THE SERIES *Sacred Sites of the Lakota*

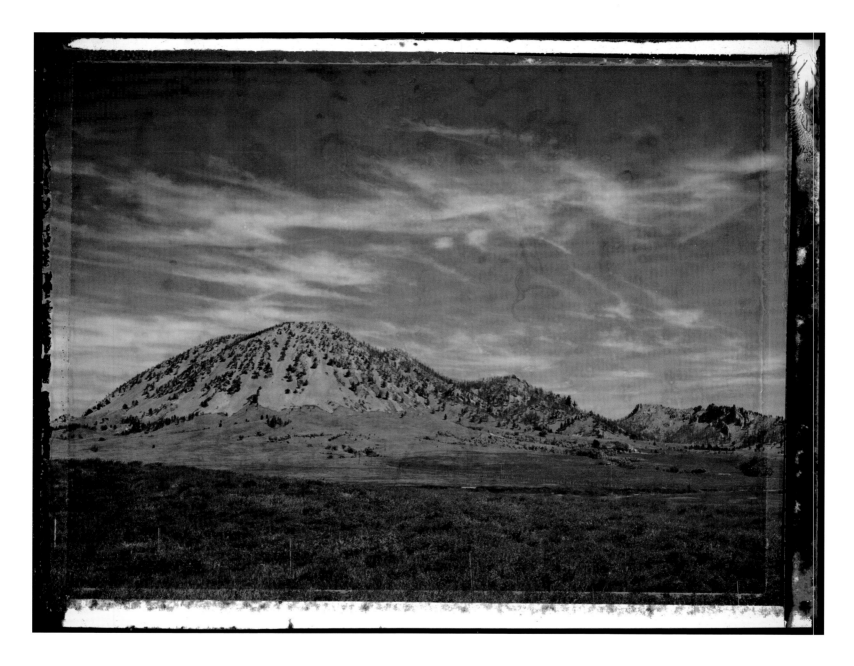

BEAR BUTTE, HOLY MOUNTAIN OF THE LAKOTA AND CHEYENNE,
BEAR BUTTE, SOUTH DAKOTA

FROM THE SERIES
Sacred Sites of the Lakota

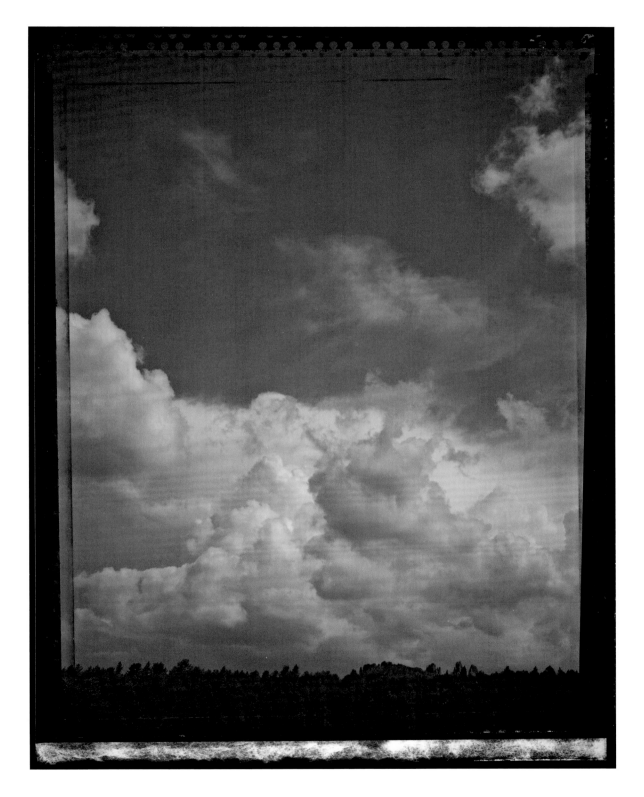

SKY OVER BLACK HILLS

BLACK HILLS, SOUTH DAKOTA

FROM THE SERIES *Sacred Sites of the Lakota*

Silent Witness: Genocide and the Landscape

Does land itself have a 'spirit'? Does it have a memory of the human drama that has transpired on its surface? Is this spirit or memory tangible; and if so can it be photographed?

These photographs, funded by a commission from the Minnesota Center for Photography, were made in and around the Badlands of South Dakota. The Lakota, who lived, prayed and hunted on this land when American expansion westward, fueled by the discovery of gold in California, necessitated its safe crossing, were one of the last holdouts of Native American resistance to the US Government's campaign to take their land and their way of life in exchange for confinement in reservations or death. The end was hastened by the discovery of gold ("the yellow metal that makes the white man crazy") and later uranium in the Black Hills. This land was and is still considered sacred by the Lakota (Sioux) and Cheyenne, among others. To this day the land, called "Paha Saha" by the Lakota, was never sold,

bartered or given away by any treaties but was simply taken. This fact has even been recognized by the US government and there have been offers of restitution made for this theft. The Native American response has always been the same: "The Black Hills are not for sale". In the government's resolve to take this land they have also perpetuated their resolve to exterminate the last of an independent spirit they could neither control nor understand. Moreover, they set a precedent that wealth and property are more important than people that still exists in our governmental policy.

I have never been drawn to photograph battle sites or graves and have always sought to portray how the sacredness of the land uplifts the human spirit. In this body of work I went to massacre grounds, battle sites and places where the US Army and the Catholic Church knowingly gave out smallpox-infected blankets to Native Americans with the sole purpose of extermination. It was very hard for me to photograph these places of such great

sadness and tragedy yet be compelled to make beautiful photographs of these places with difficult histories.

Does this landscape, as 'Silent Witness', hold a memory of these past genocidal tragedies or is it just land that we humans have forced our drama upon? Either answer is all right as long as you take time to feel the space and sky and breathe in its history with an open heart. Personally, I feel there is a memory the land holds but maybe not in the normal, tangible way we think of 'memory'. It is more important to realize the tragic history played out on this land and our government's extermination policy against Native people and also to remember and acknowledge that this is our own history.

>

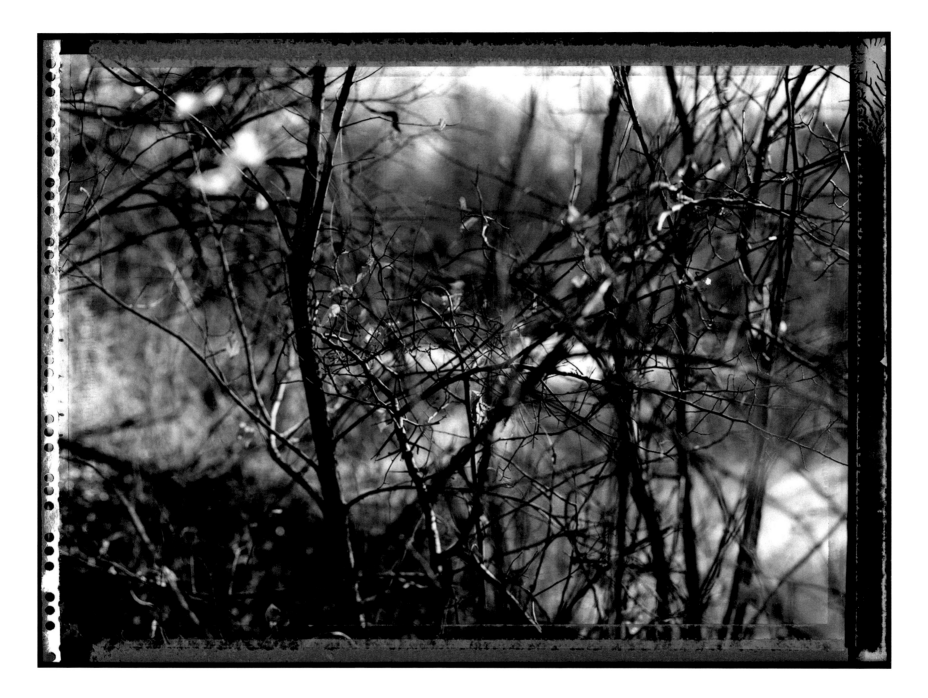

LOOKING THROUGH BUSHES, WOUNDED KNEE MASSACRE SITE

WOUNDED KNEE, SOUTH DAKOTA

FROM THE SERIES

Silent Witness: Genocide and the Landscape

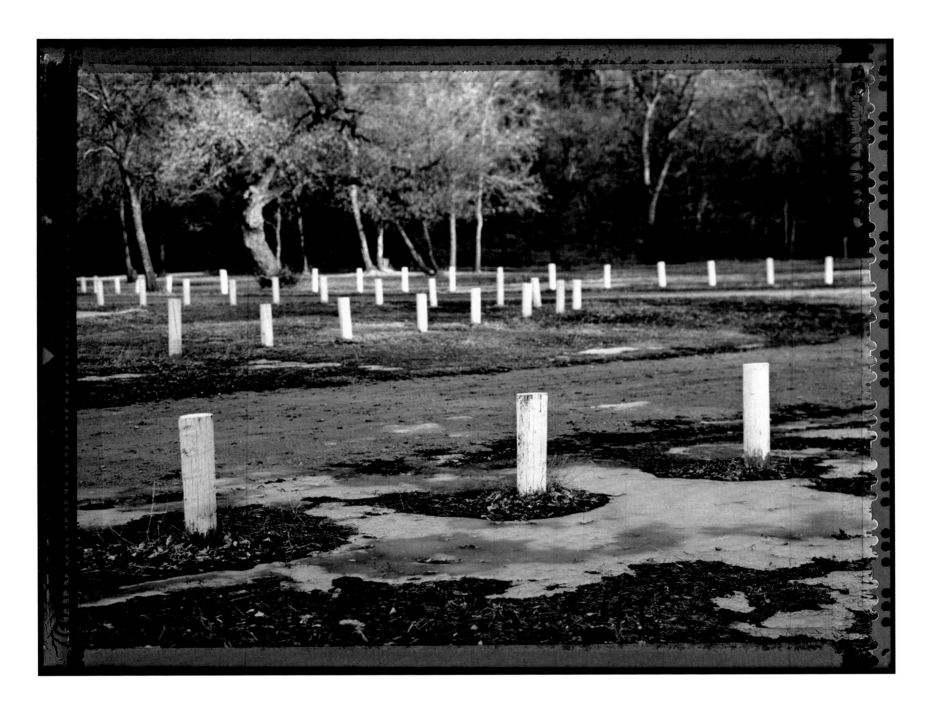

PARKING LOT POSTS, ROSEBUD CREEK MASSACRE SITE

ROSEBUD RESERVATION, SOUTH DAKOTA

FROM THE SERIES

Silent Witness: Genocide and the Landscape

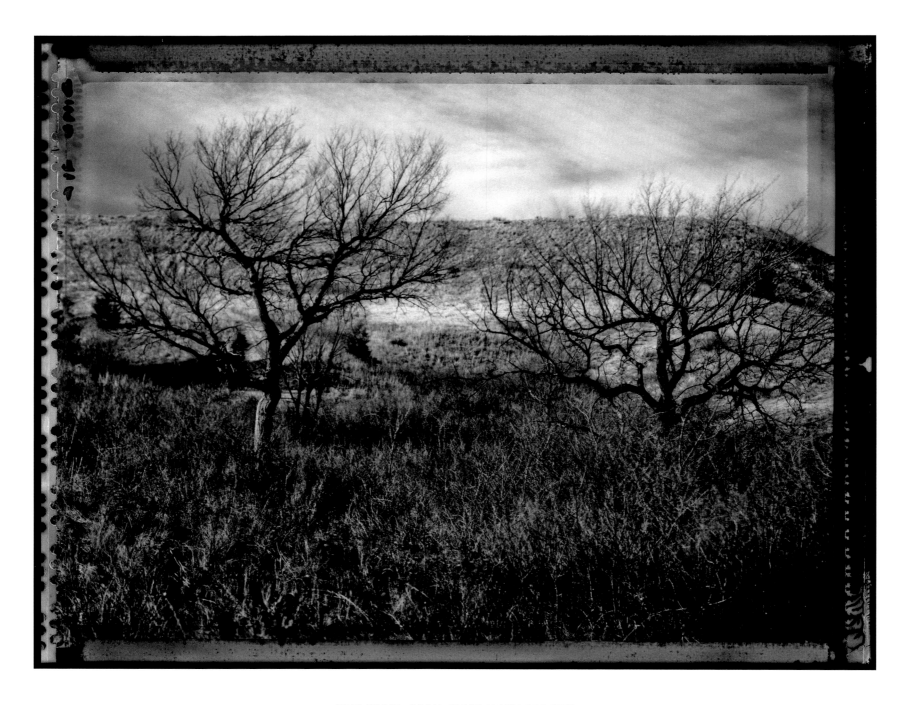

TWO TREES, CORN CREEK MASSACRE SITE

CORN CREEK, SOUTH DAKOTA

FROM THE SERIES

Silent Witness: Genocide and the Landscape

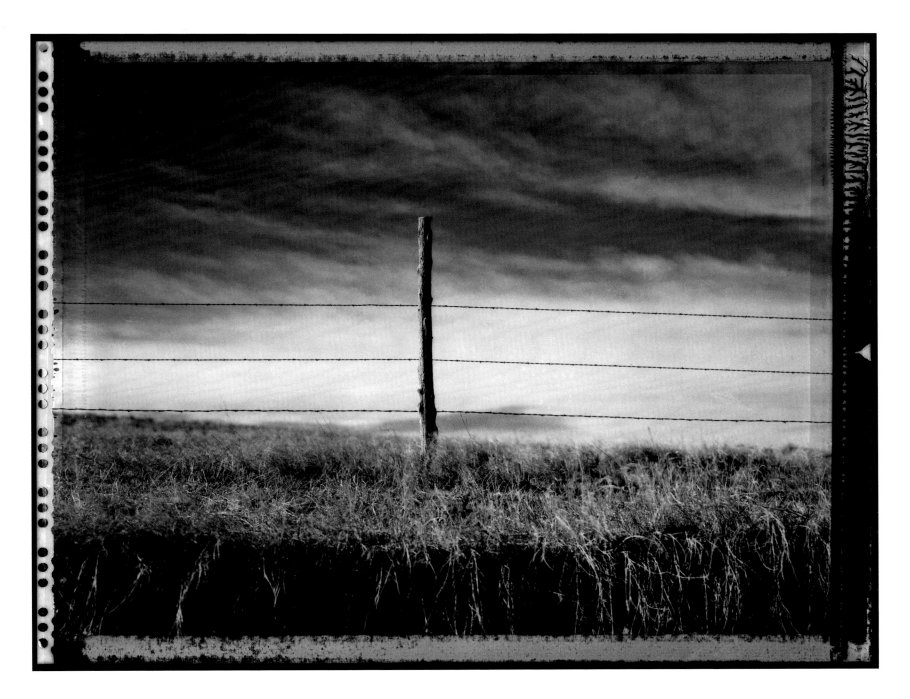

FENCE POST, BOX BUTTE MASSACRE SITE

BOX BUTTE, SOUTH DAKOTA

FROM THE SERIES

Silent Witness: Genocide and the Landscape

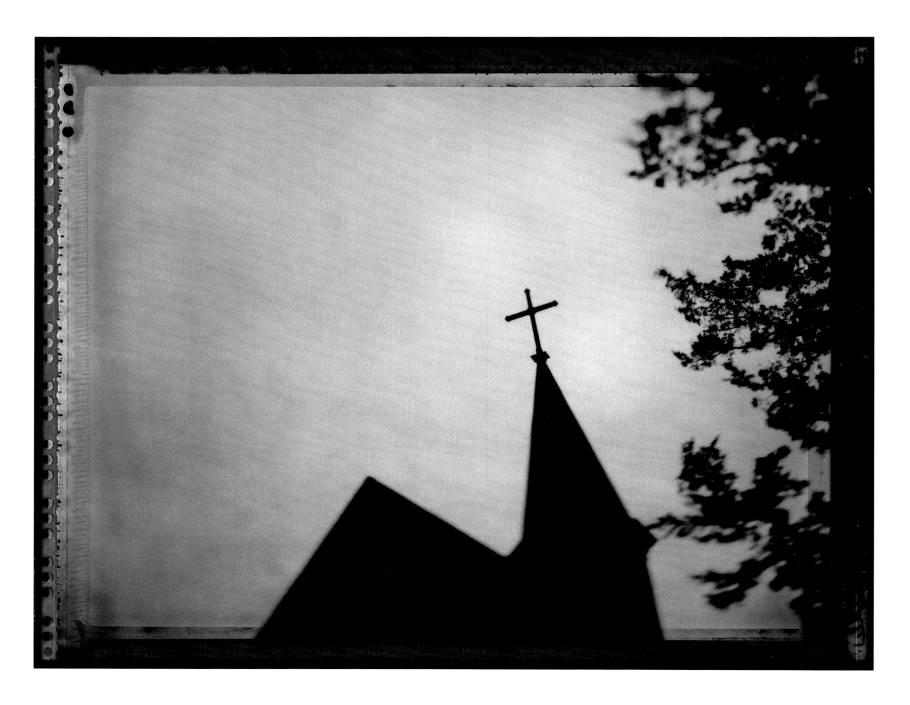

CHURCH WHERE SMALL POX INFECTED BLANKETS WERE GIVEN OUT

PINE RIDGE, SOUTH DAKOTA

FROM THE SERIES

Silent Witness: Genocide and the Landscape

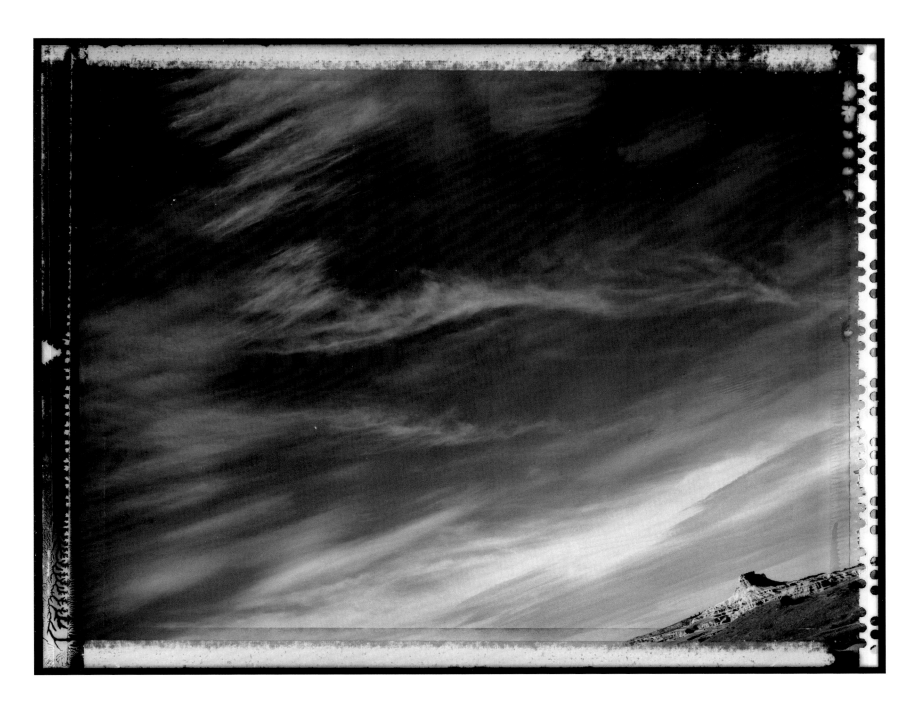

SKY OVER WARRIORS BONES

BOX BUTTE, SOUTH DAKOTA

FROM THE SERIES

Silent Witness: Genocide and the Landscape

Disappearing Green Space

What will be lost and what will be gained if our remaining open spaces continue to be developed? Does the development of the land change or even remove its 'spirit'? Does that development impede our ability to connect with spirit or a sense of the divine in the land? Or is land just empty space to be used for the common good and thus development an inevitable byproduct of 'progress'?

This series of photographs, funded by a McKnight Foundation Photography Fellowship, explores how the American landscape is being quickly, profoundly and permanently changed by rampant over-development. I strongly relate to the words of singer/

songwriter Greg Brown as he sings "I watched my country turn into a coast-to-coast strip mall" in the song "The Poet Game". Although the outer edge of suburbia, where it intersects with farms, forests and fields, is being hit the hardest, it is happening in all areas of the country, both rural and urban. Once lost, these open spaces will most likely never return to their original natural state and can never be called 'undeveloped' again.

My intent is not to document the destruction of forests, fields and vacant lots but to explore the emotional and visual impact this brings, as what is lost cannot be reclaimed. In losing this original

state of nature I believe we lose a part of ourselves as well. My interest is to photograph the emotional impact of this destruction or loss rather than catalog how and where it is happening. I want to experience, interpret and know for myself this land, with its history and its secrets, that we are losing forever to development.

>

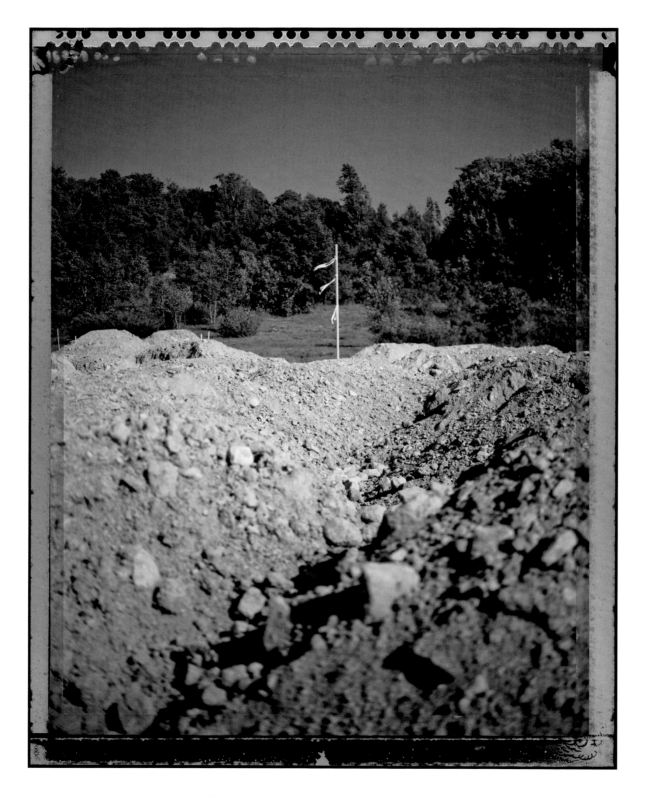

SURVEYORS FLAG AT NEW GOLF COURSE

DOOR COUNTY, WISCONSIN

FROM THE SERIES *Disappearing Green Space*

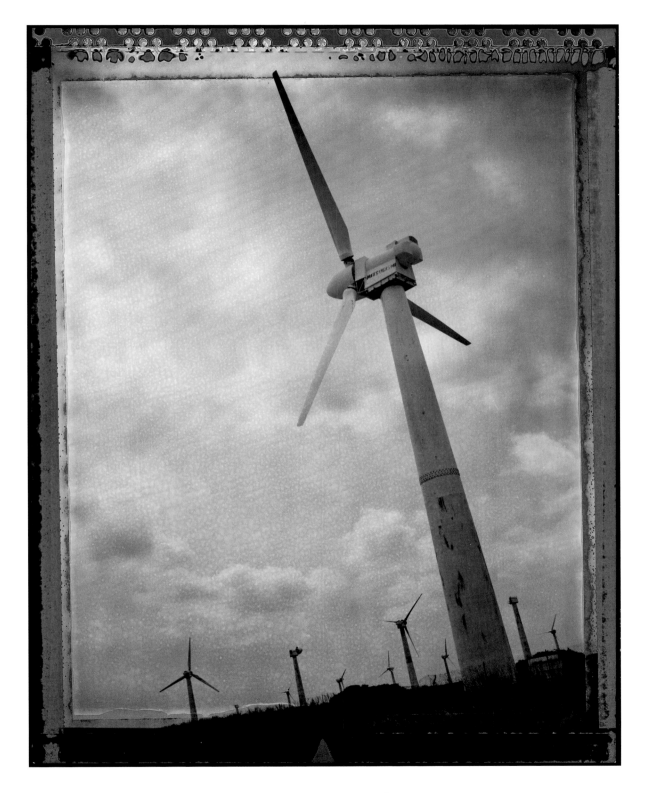

ABANDONED WIND FARM

BIG ISLAND, HAWAII

FROM THE SERIES *Disappearing Green Space*

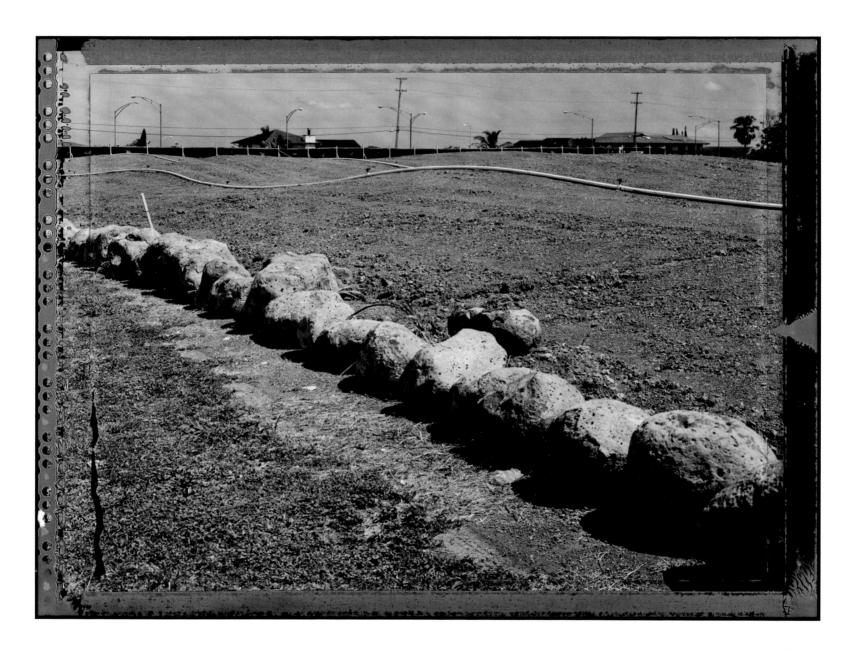

NEW HOUSING DEVELOPMENT

KAUAI, HAWAII

FROM THE SERIES

Disappearing Green Space

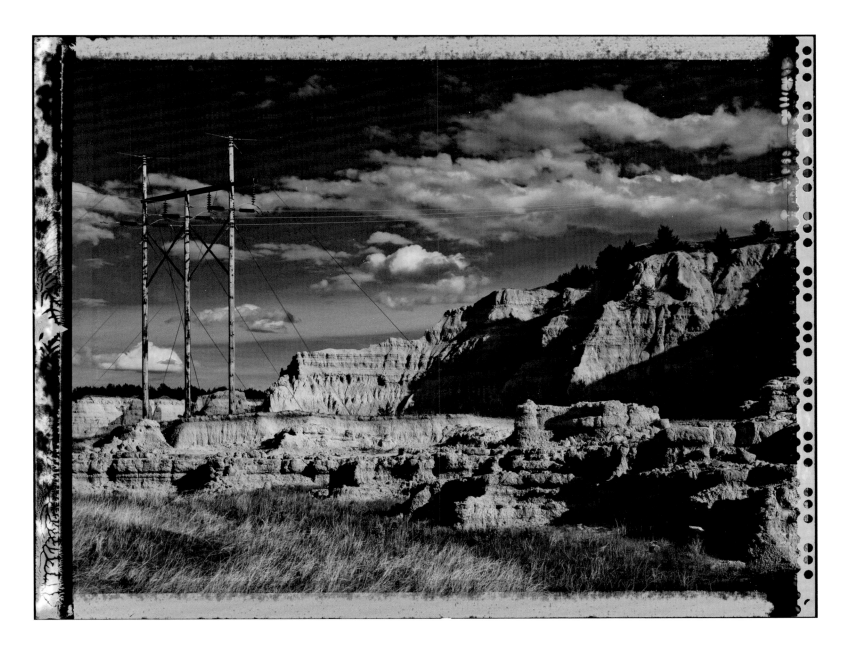

POWERLINES AT WOLF TABLE MOUNTAIN

PINE RIDGE RESERVATION, SOUTH DAKOTA

FROM THE SERIES

Disappearing Green Space

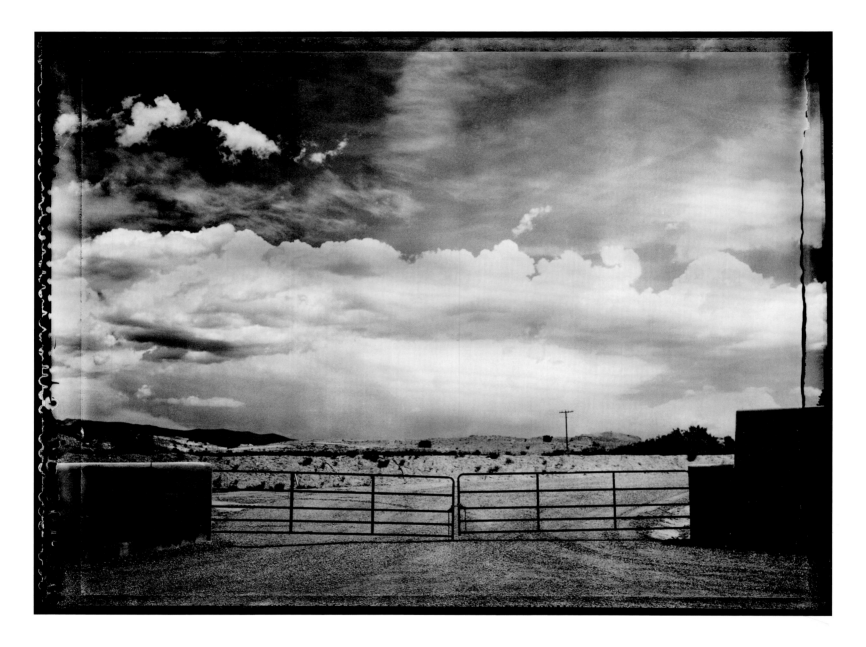

BUILDING NEW GOLF COURSE IN THE DESERT

ESPANOLA, NEW MEXICO

FROM THE SERIES

Disappearing Green Space

NEW CONSTRUCTION ON UNIVERSITY AVENUE

SAINT PAUL, MINNESOTA

FROM THE SERIES

Disappearing Green Space

The Sacred Landscape

Are 'Earth' and 'Self' separate identities? Or do they emanate from the same source? Does this matter and how does it affect our perception of the world around and in us?

I like to think of my photography as visual metaphors. I photograph to learn how I feel in response to the subject and then express that through the print. For the viewer, I hope my images act as offerings of visual poems or prayers, meant only as a departure point for the viewer's own visual or spiritual journey.

I also photograph to discover how I feel about the world and my current place, or lack thereof, in it. It is my response to the world around me, a fusing of inner and outer worlds, using, by transference, the physical reality of the outer world to represent my inner state of being. I want to embrace both great beauty and great sadness equally.

The act of making, and not taking photos is my daily lesson to slow down and be aware of what presents itself. It is the act of paying attention by honoring and honoring by paying attention. Photography is my attempt to recognize and then honor the spirit or soul that inhabits all things, both animate and inanimate.

DOUGLAS BEASLEY

>

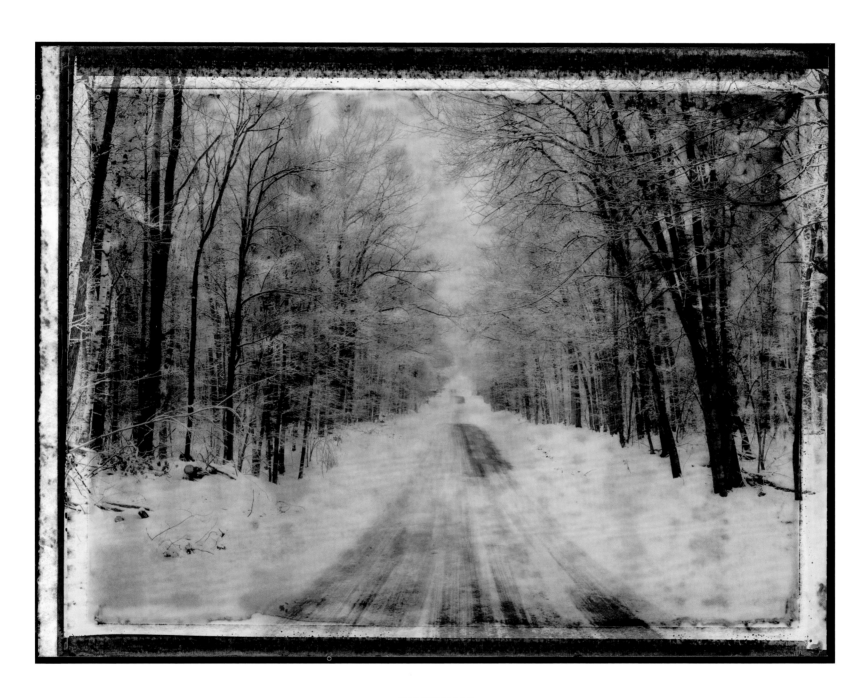

SNOWY ROAD

BURNETT COUNTY, WISCONSIN

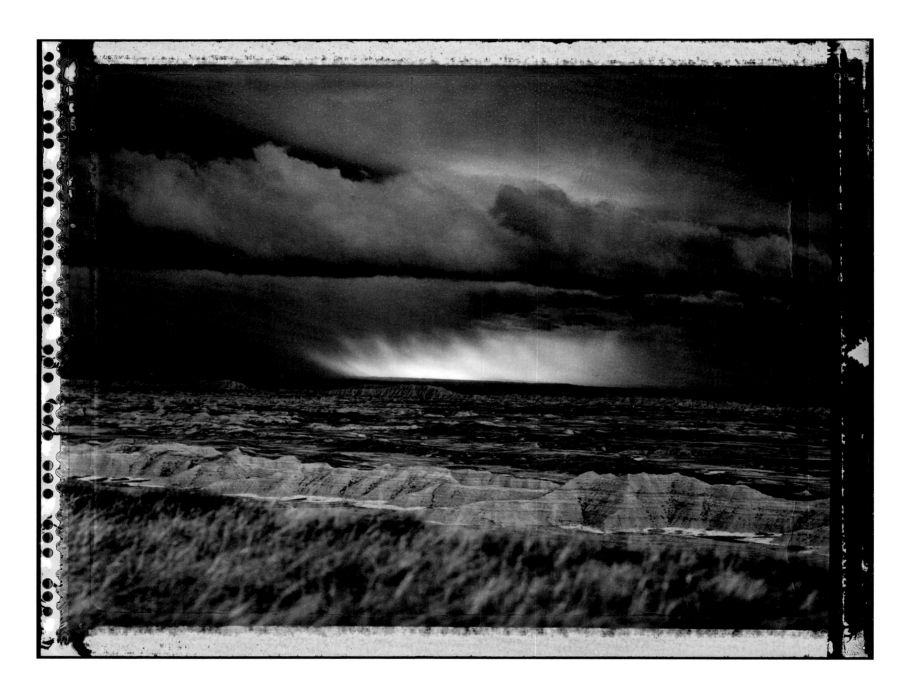

APPROACHING STORM, SHEEP TABLE

BADLANDS, SOUTH DAKOTA

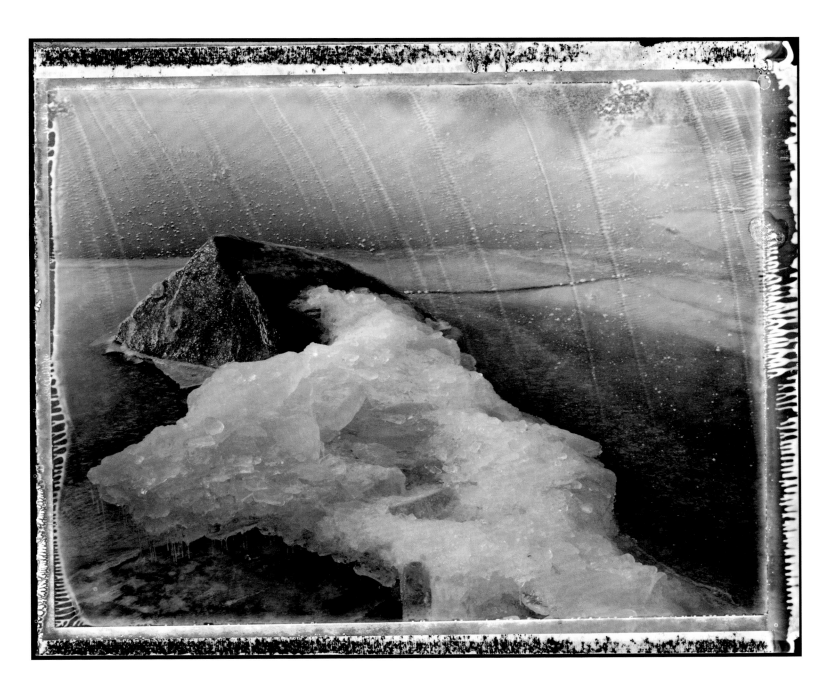

ROCK AND ICE

LAKE SUPERIOR, MINNESOTA

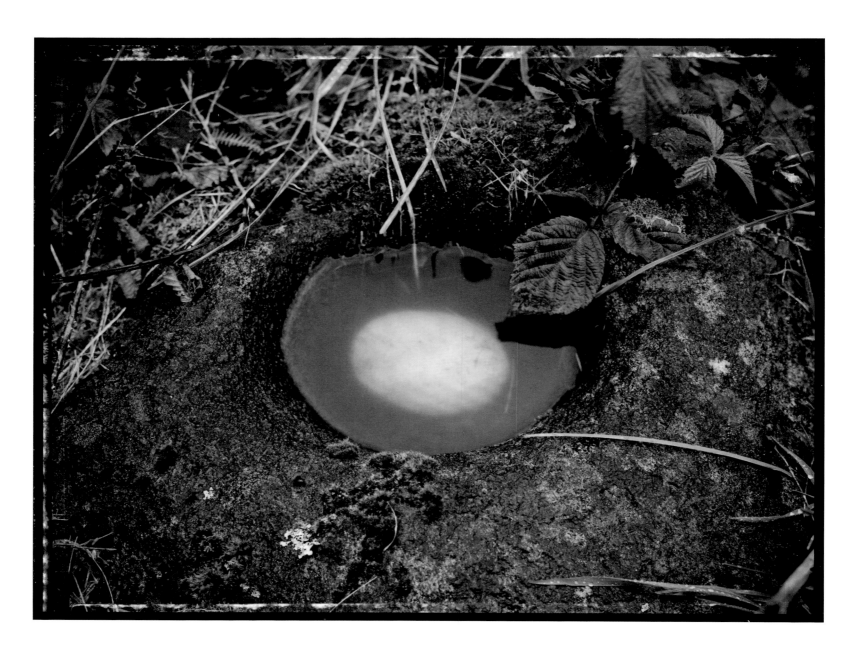

CURE STONE BY HOLY WELL

COUNTY MAYO, IRELAND

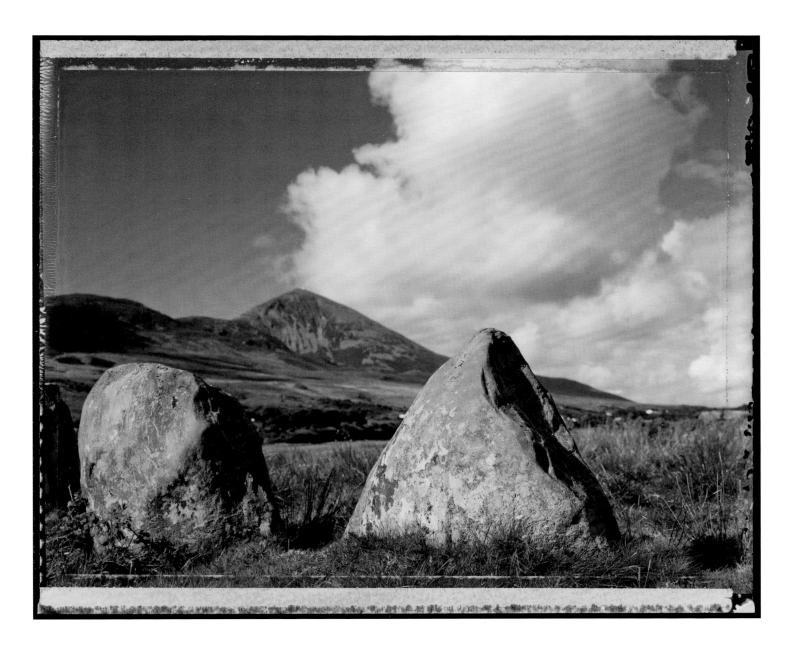

STANDING STONES IN FRONT OF IRELAND'S HOLY MOUNTAIN

CROUGH PATRICK, IRELAND

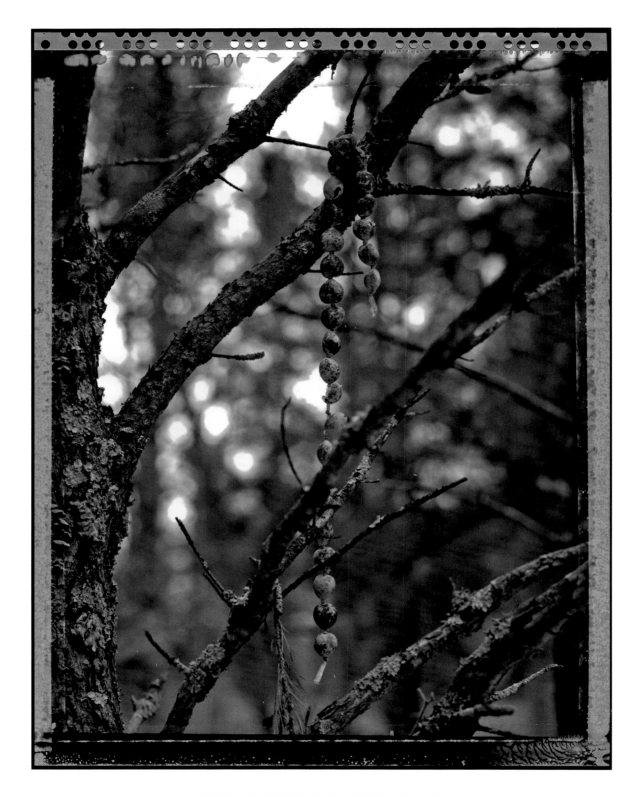

HAWAIIAN PRAYER BEADS FOUND AT CABIN

TRADE RIVER, WISCONSIN

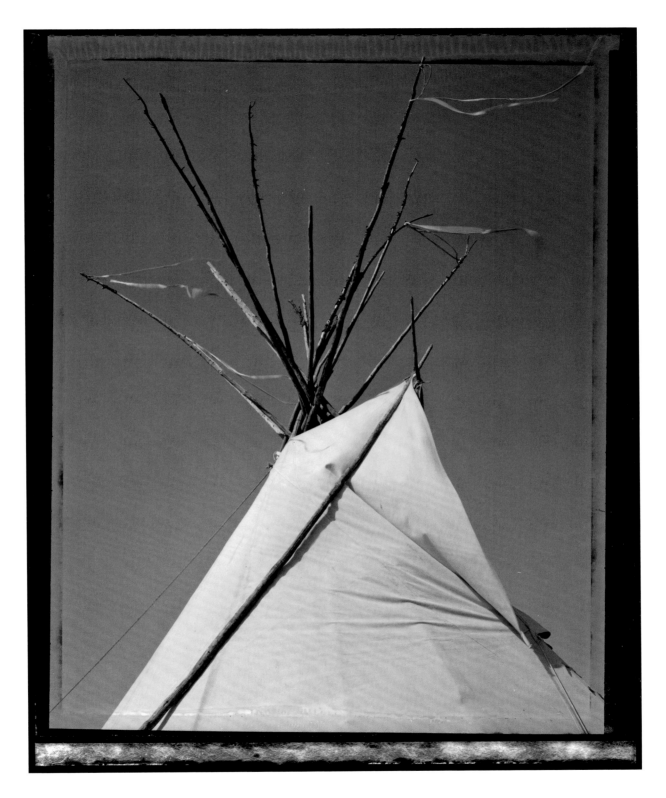

TIPI

RED LAKE RESERVATION, NORTHERN MINNESOTA

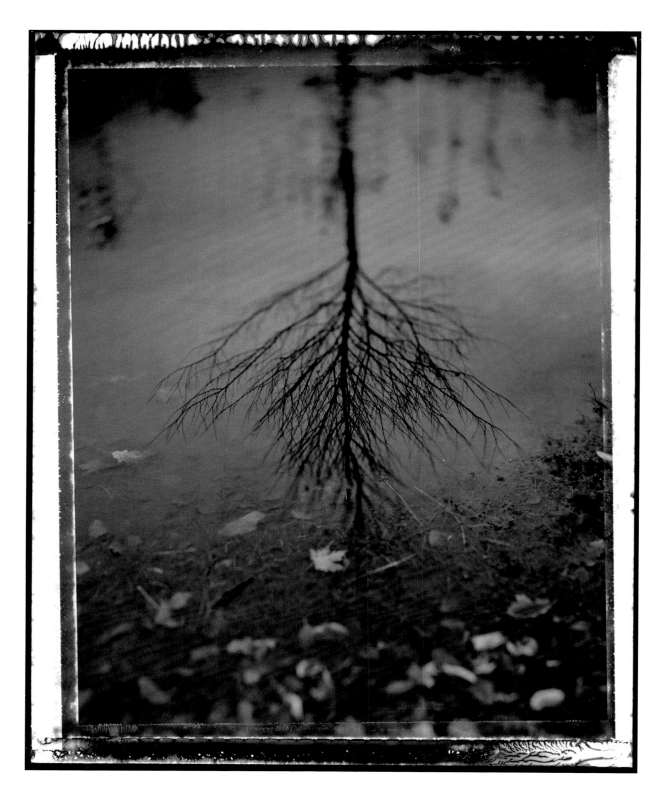

TREE REFLECTION WITH LEAVES

COMO LAKE, SAINT PAUL, MINNESOTA

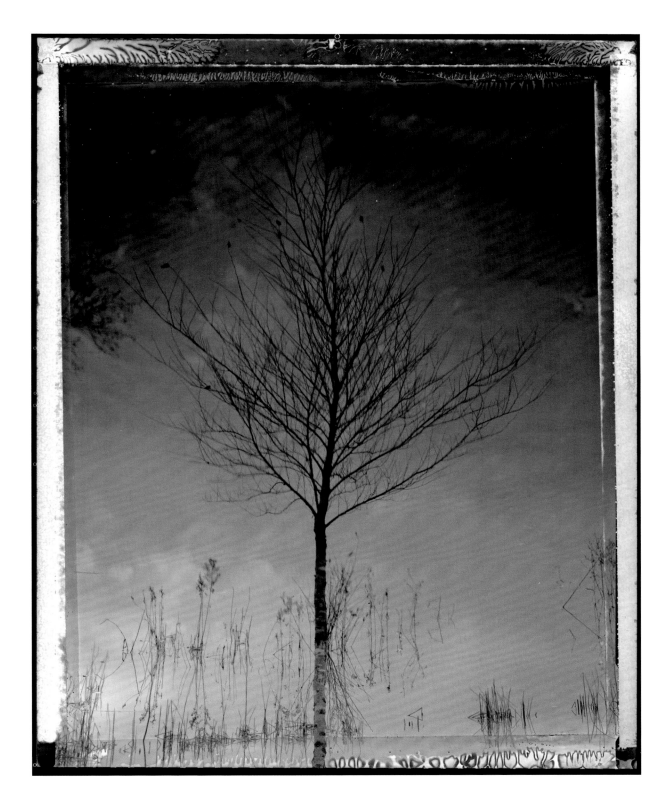

TREE REFLECTION WITH REEDS

COMO LAKE, SAINT PAUL, MINNESOTA

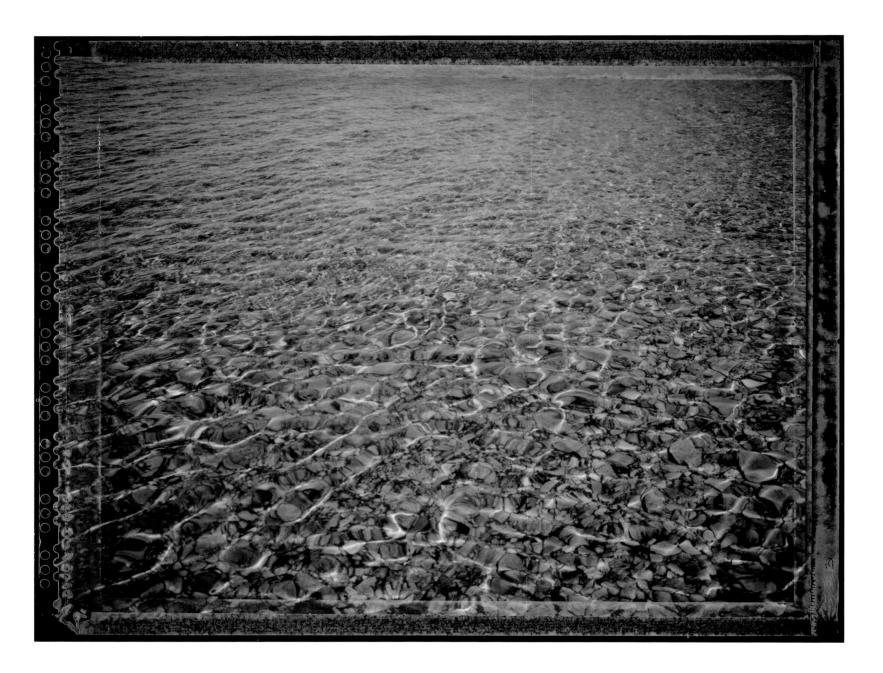

LAKE MICHIGAN

DOOR COUNTY, WISCONSIN

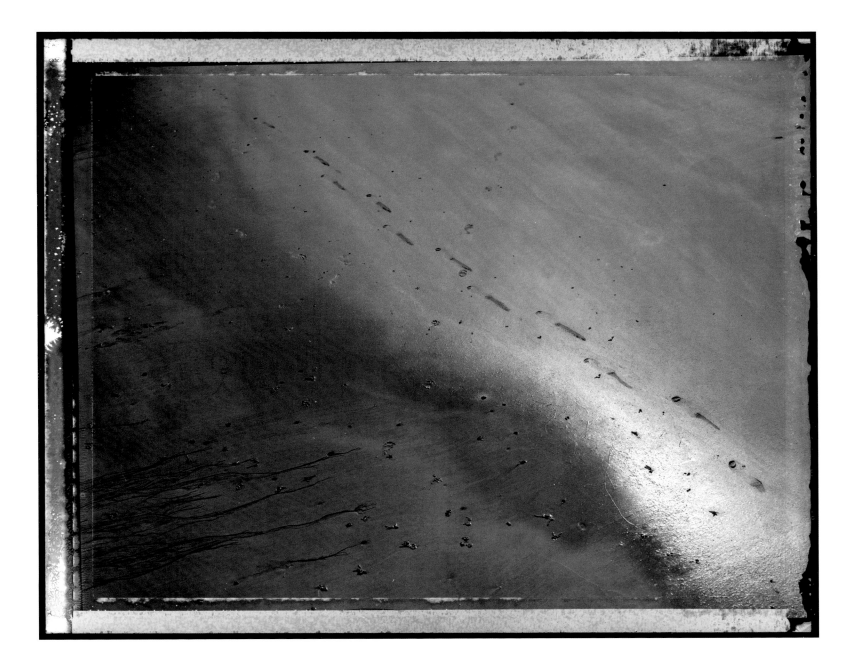

FOOTPRINTS IN SAND

CONNEMARA, IRELAND

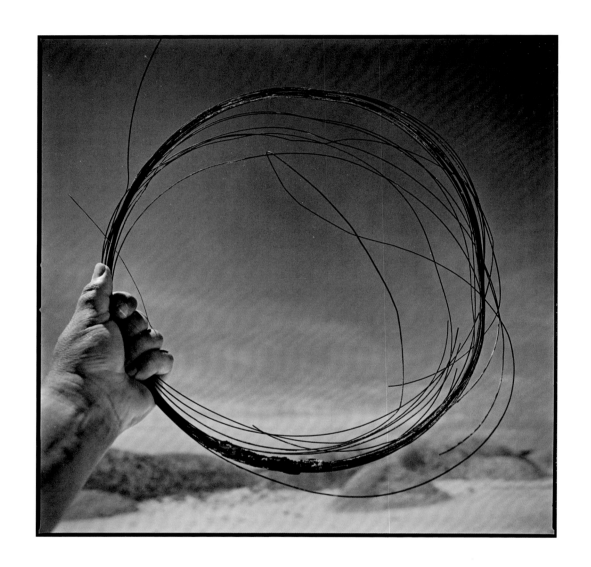

SELF-PORTRAIT AS ENZO

BADLANDS, SOUTH DAKOTA

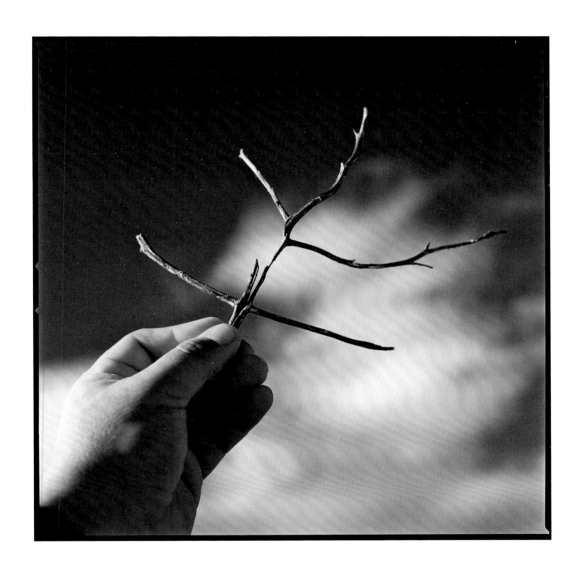

SELF-PORTRAIT AS TWIG

BADLANDS, SOUTH DAKOTA

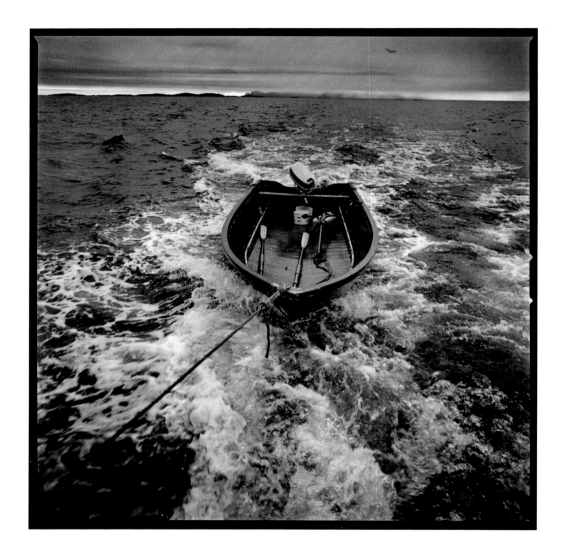

SELF PORTRAIT AS EMPTY BOAT

NORWAY

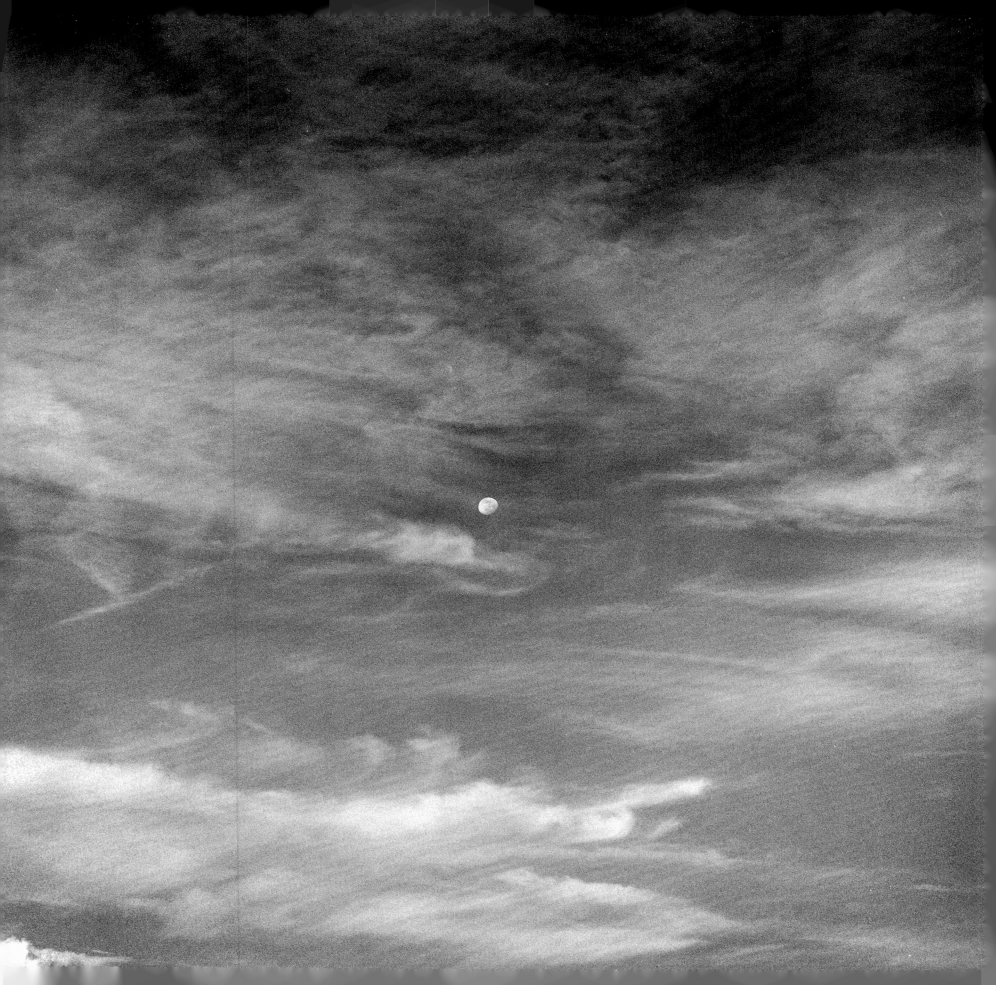

Be still with yourself

Until the object of your attention

Affirms your presence.

MINOR WHITE

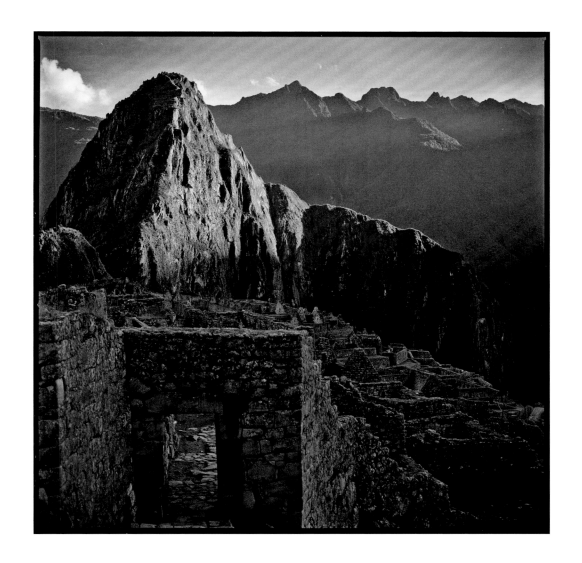

SOLSTICE SUNRISE OF THE NEW MILLENNIUM

MACHU PICCHU, PERU

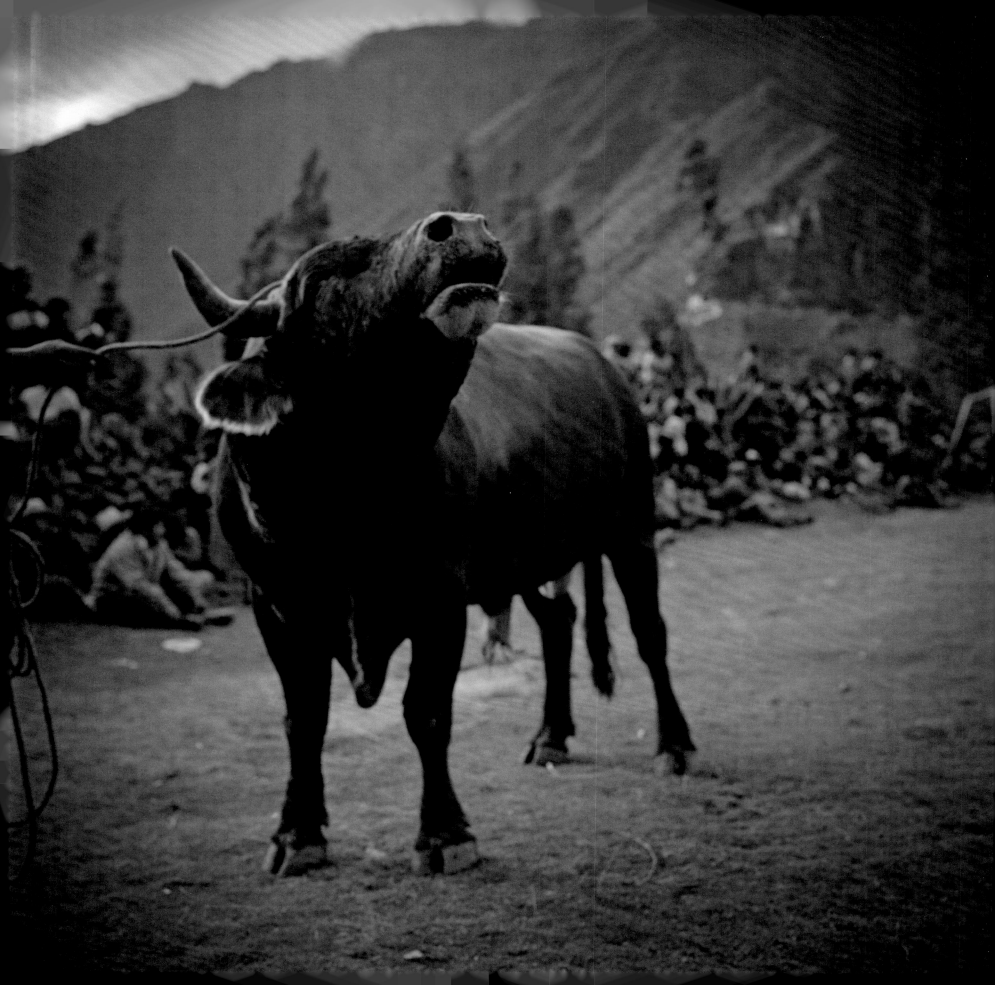

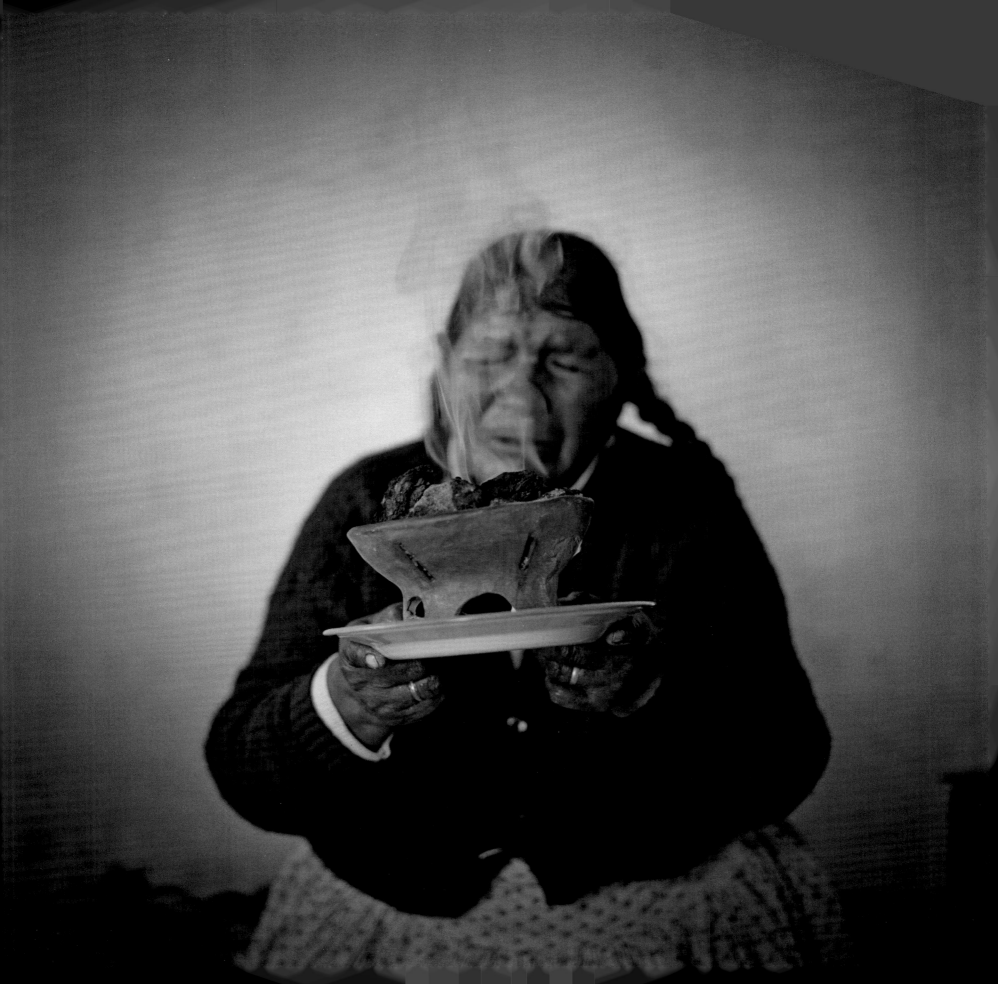

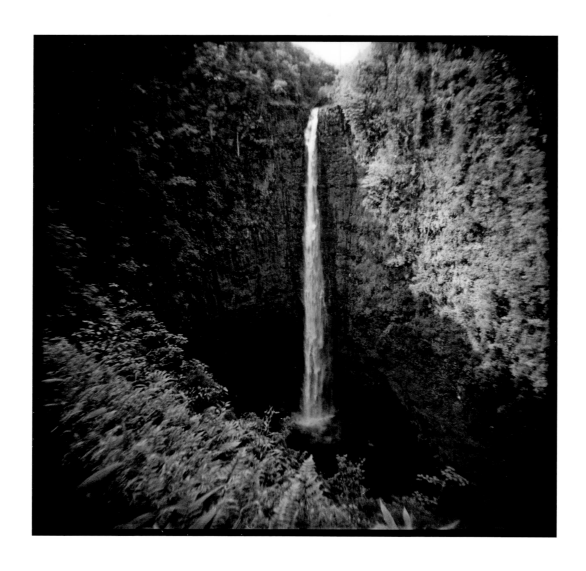

AKAKA FALLS

BIG ISLAND, HAWAII

MADE WITH PLASTIC TOY CAMERA

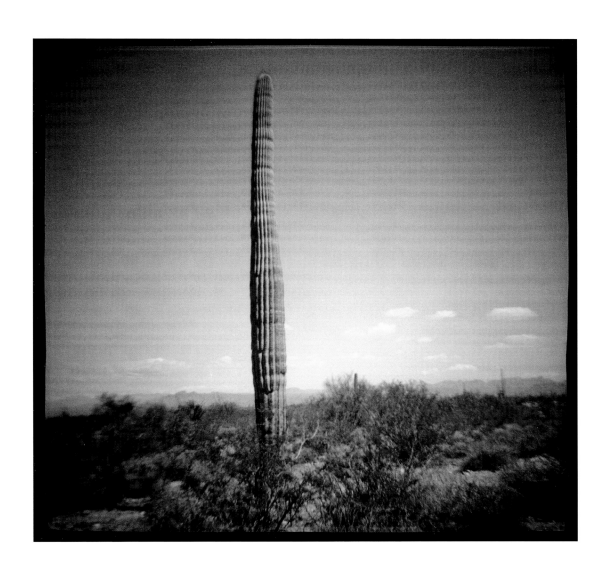

CACTUS

SNOWFLAKE, ARIZONA

MADE WITH PLASTIC TOY CAMERA

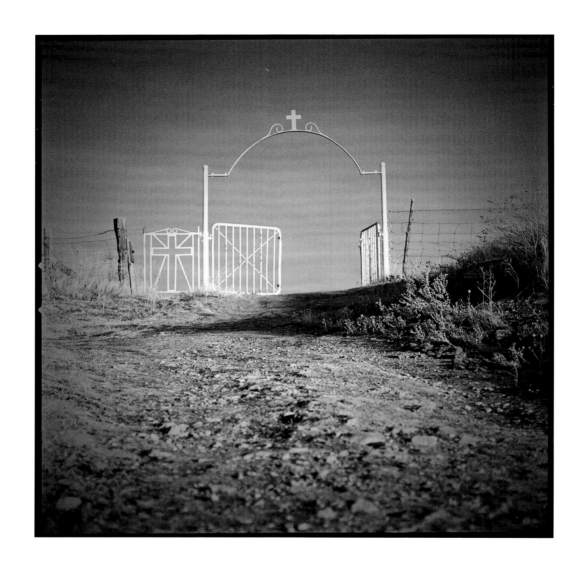

ROAD TO RED CLOUD'S GRAVE

PINE RIDGE RESERVATION, SOUTH DAKOTA

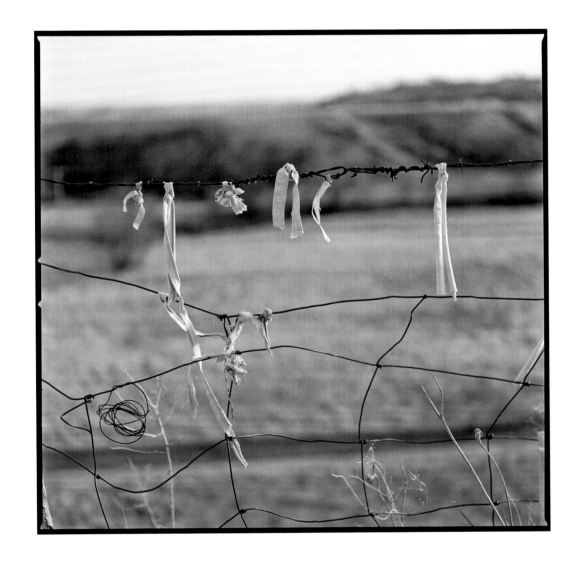

PRAYER TIES IN FENCE BY RED CLOUD'S GRAVE

PINE RIDGE RESERVATION, SOUTH DAKOTA

When we open ourselves to the silence, there is only the listening. Love lives in the silence.

RILKE

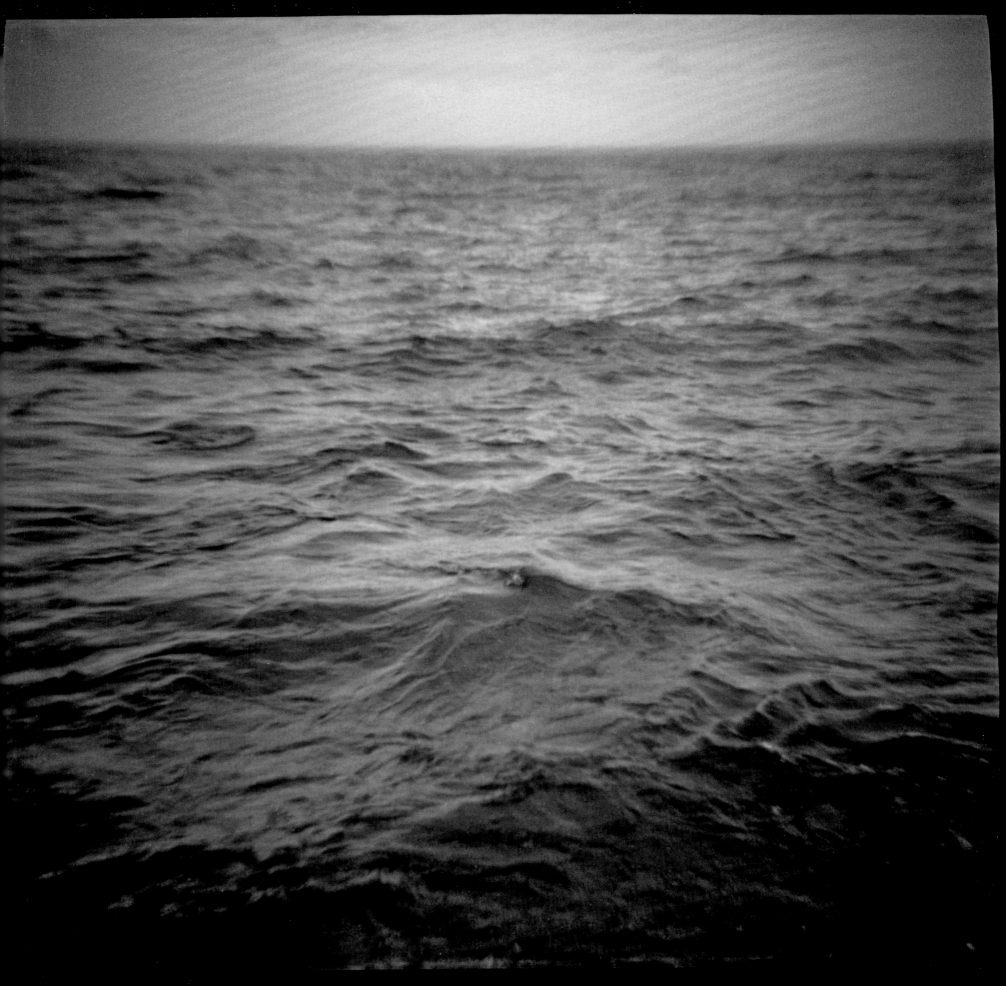

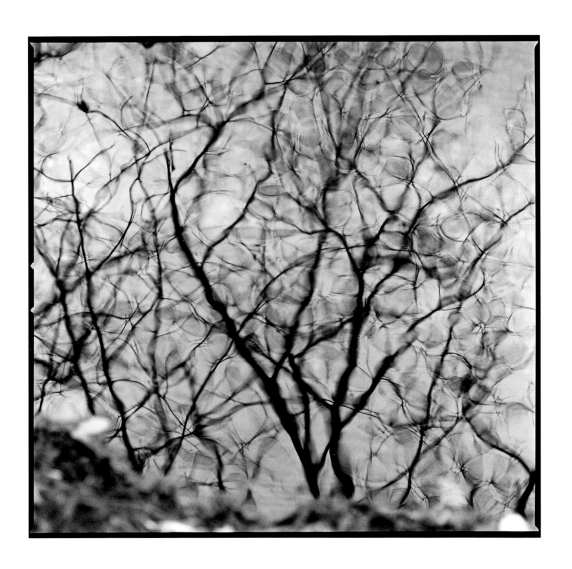

REFLECTION

SNAKE RIVER, MINNESOTA

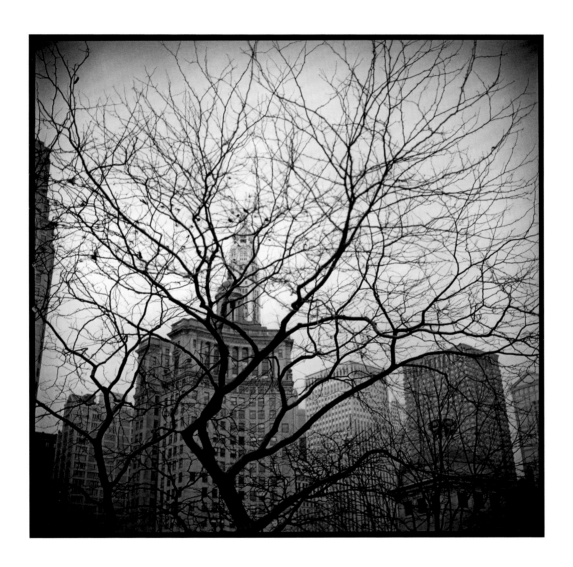

TREES AND BUILDINGS

DOWNTOWN CHICAGO, ILLINOIS

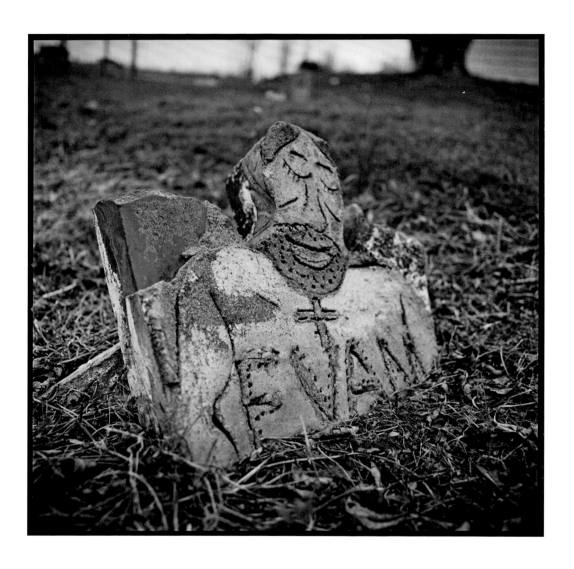

EVAM. HANDMADE GRAVE OF FREED SLAVE

RURAL MISSISSIPPI

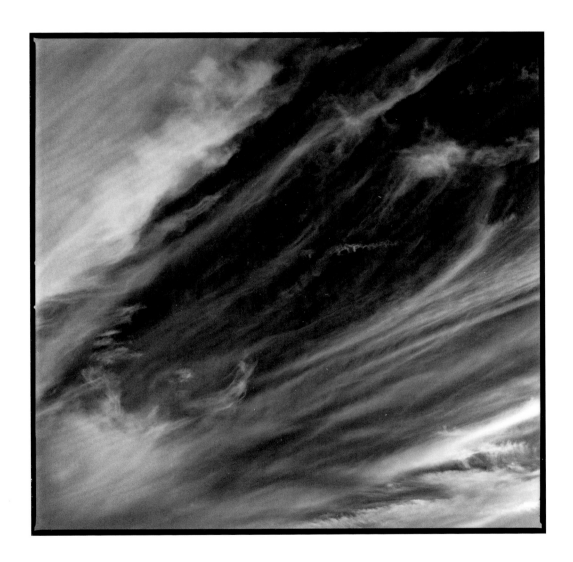

CLOUDS AND SKY

BREITENBUSH HOT SPRINGS, OREGON

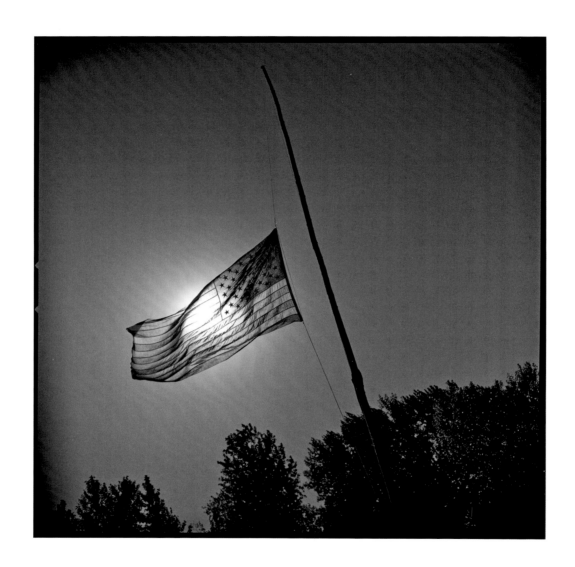

AMERICAN FLAG ON 9/11

SAUVIE ISLAND, OREGON

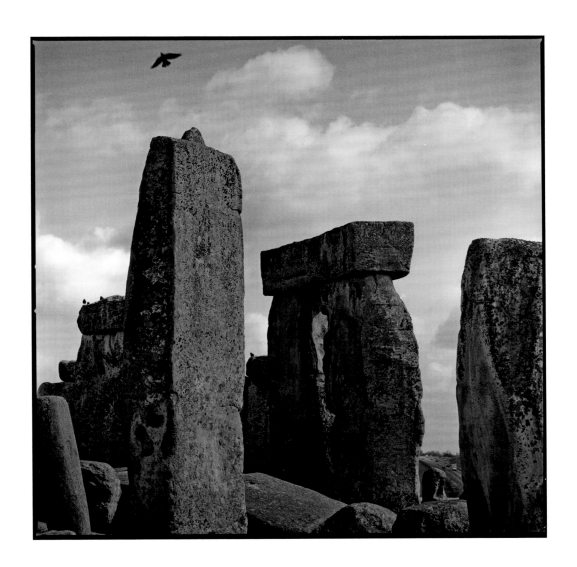

BIRD OVER STONEHENGE

ENGLAND

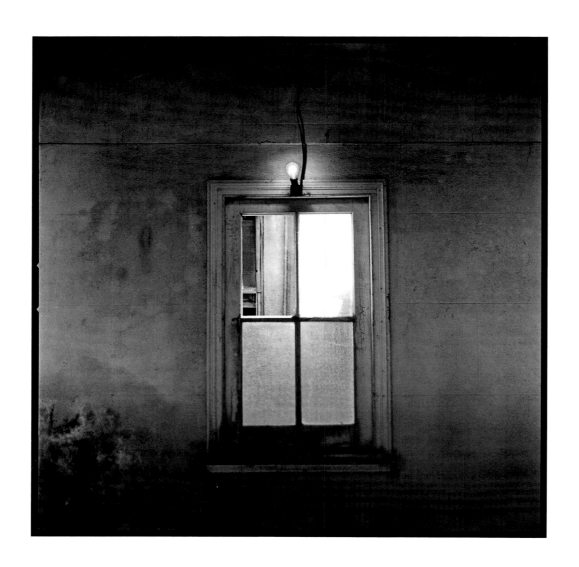

LIGHT IN STAIRWELL

HAVANA, CUBA

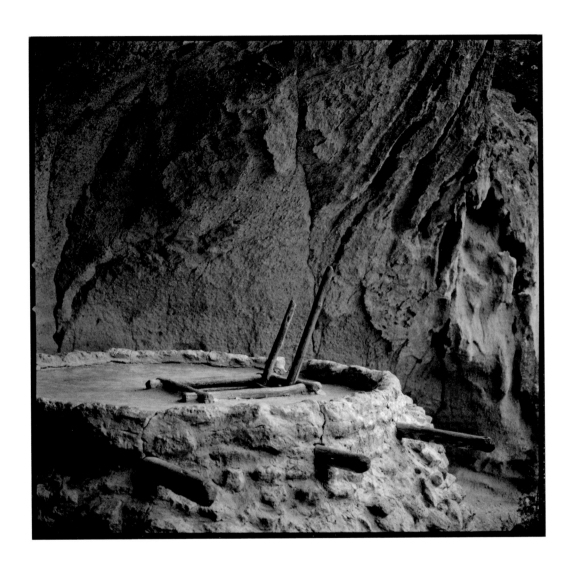

KIVA

BANDELIER, NEW MEXICO

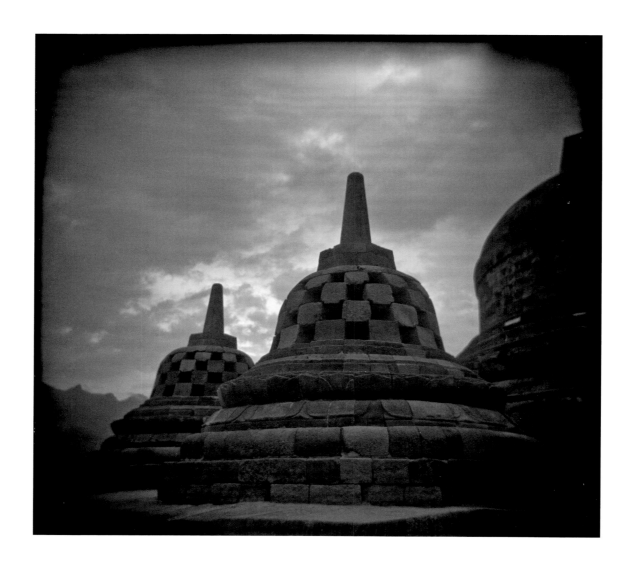

BAROBODOUR

JAVA. INDONESIA

MADE WITH PLASTIC TOY CAMERA

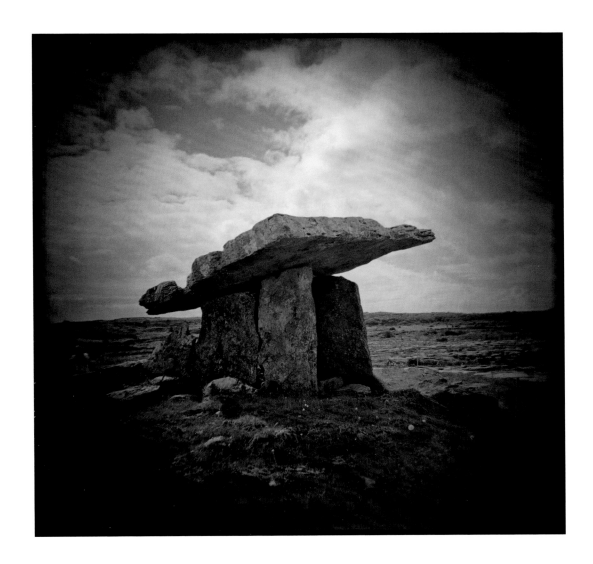

POULNABRONE DOLMEN

THE BURREN, COUNTY CLARE, IRELAND

MADE WITH PLASTIC TOY CAMERA

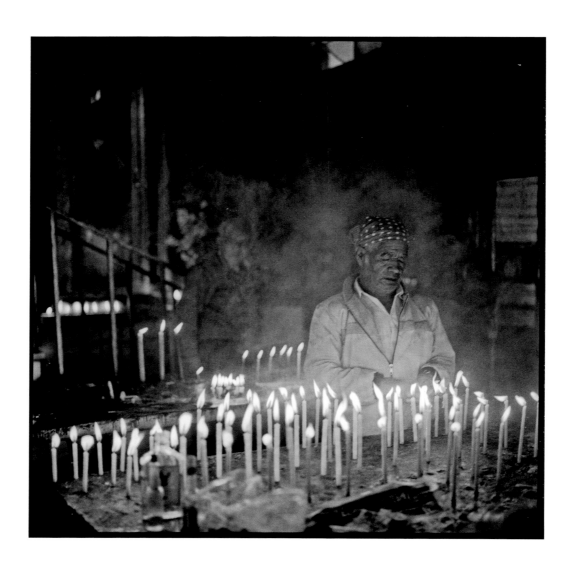

MAYAN MAN PRAYING TO MAXIMON

SAN ANDREAS IZTAPA. GUATEMALA

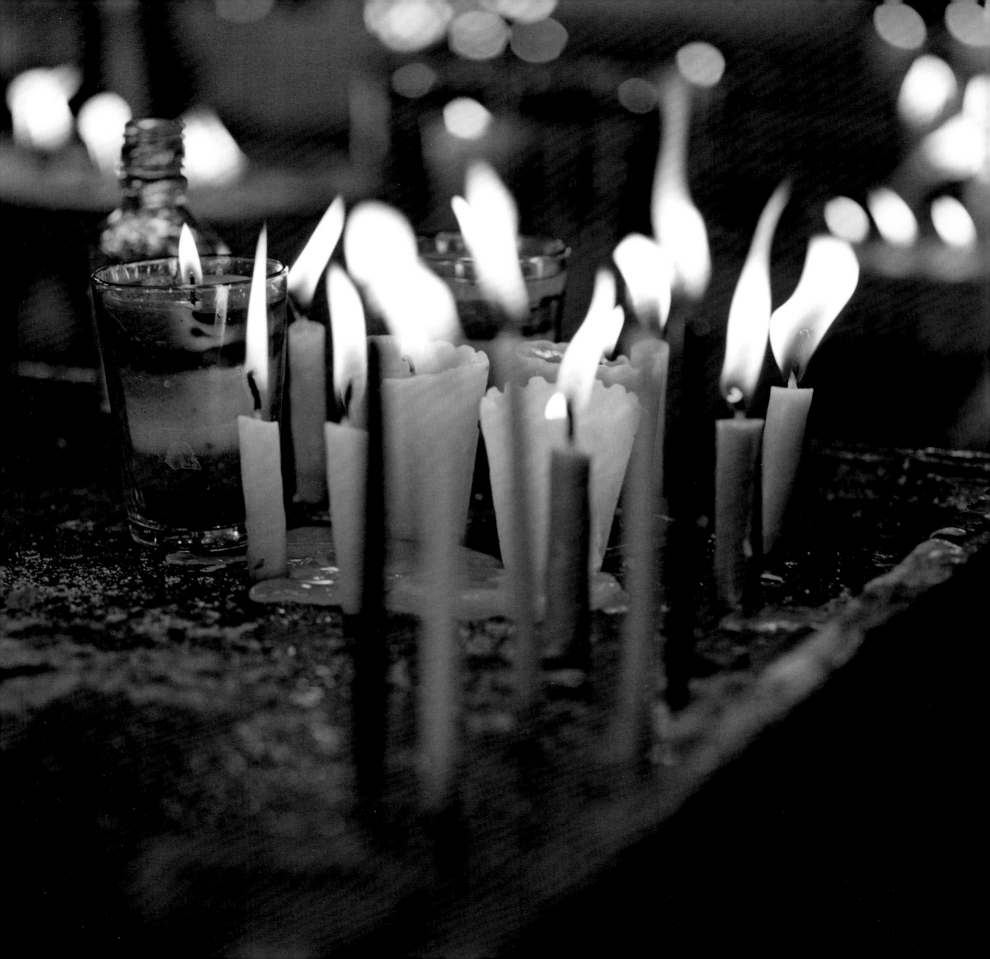

Just remain in the center, watching. And then forget that you are there.

LAO-TZU

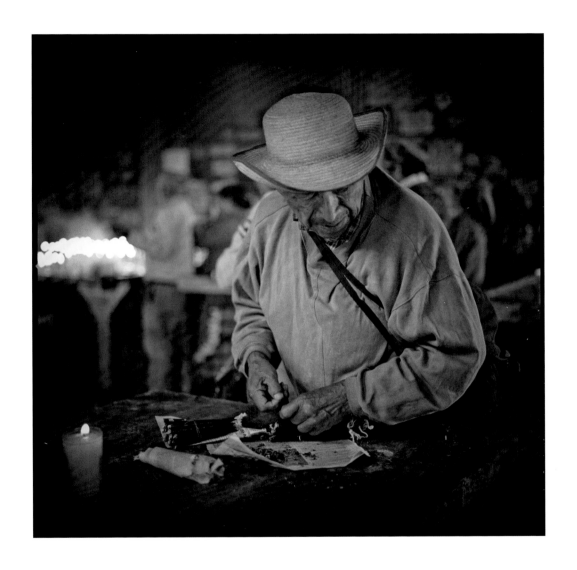

MAYAN MAN PREPARING OFFERING FOR MAXIMON

SAN ANDREAS DE IXTAPA, GUATEMALA

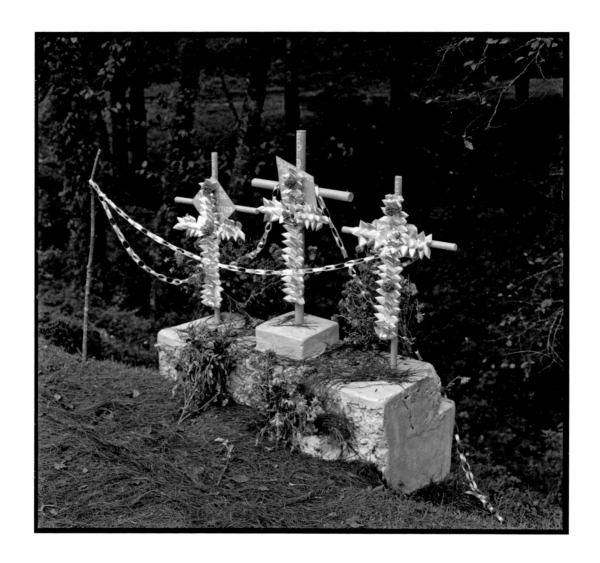

ROADSIDE CROSSES FOR GIRLS KILLED BY BUS

ROAD TO LAKE ATITLAN, GUATEMALA

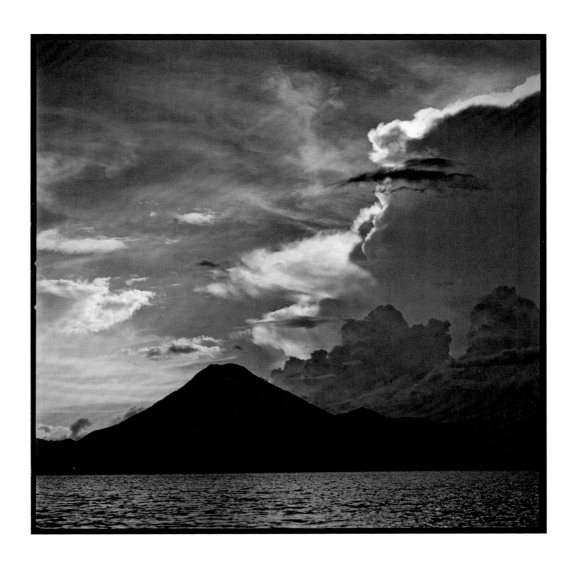

VOLCANO AND SKY OVER WATER

LAKE ATITLAN, GUATEMALA

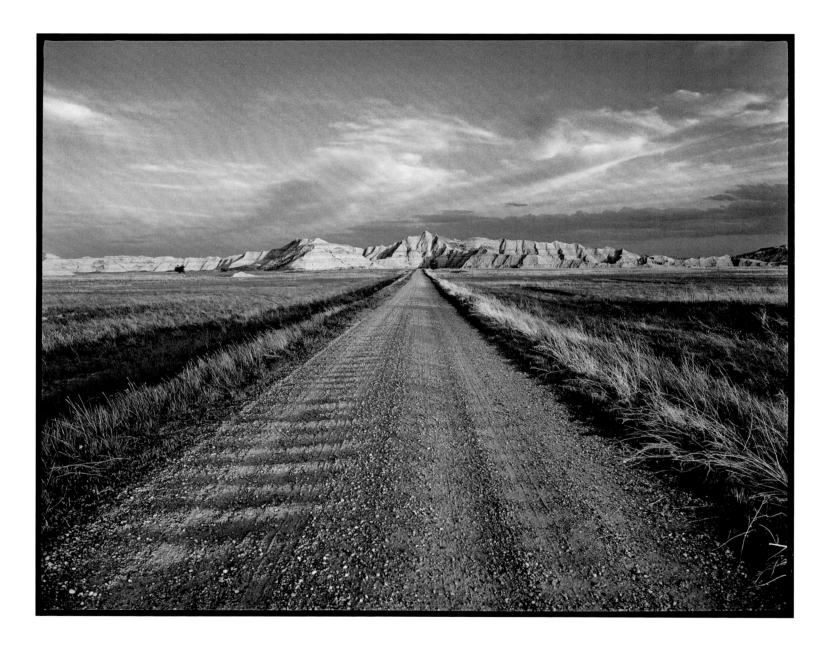

ROAD TO SHEEP TABLE

BADLANDS, SOUTH DAKOTA

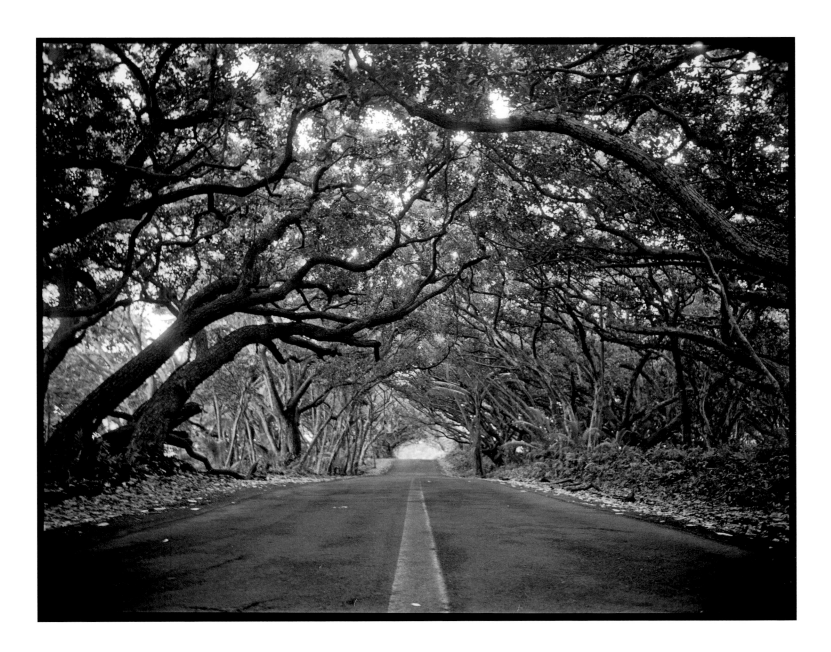

THE RED ROAD IN PAHOA

BIG ISLAND, HAWAII

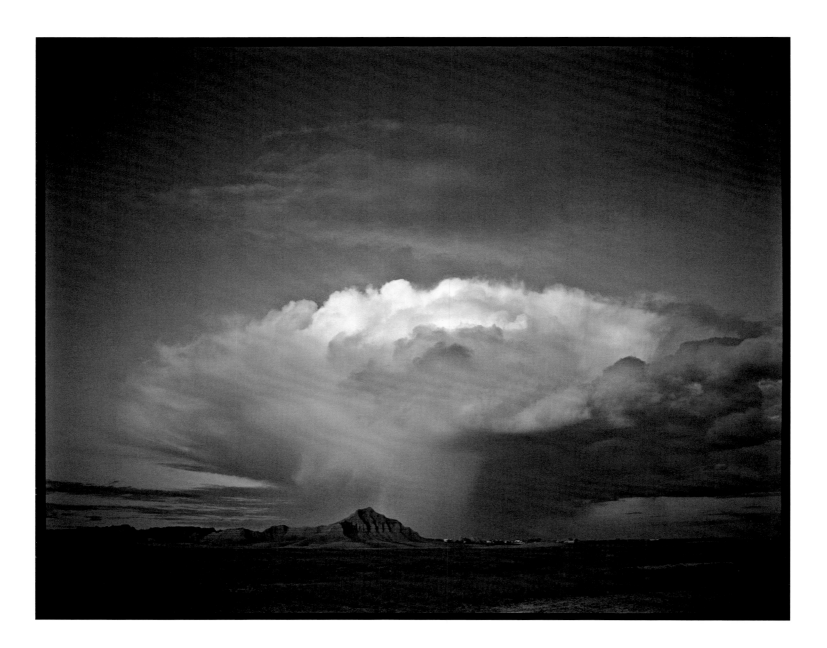

THUNDERHEAD OVER INTERIOR

BADLANDS, SOUTH DAKOTA

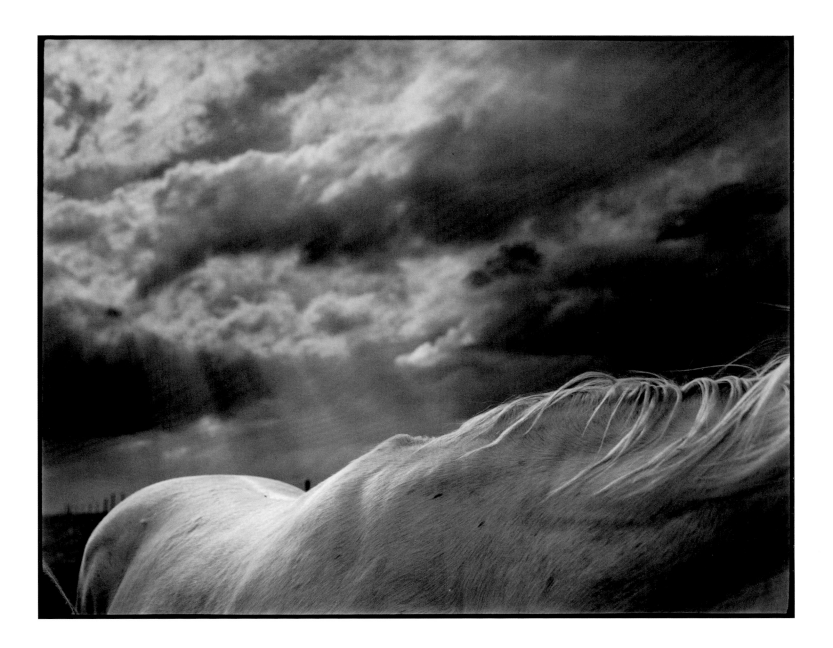

HORSE IN BADLANDS

SOUTH DAKOTA

Every step you take on earth should be a prayer. And if every step you take is a prayer, then you will always be walking in a sacred manner.

CHARMAINE WHITE FACE

OGLALA LAKOTA

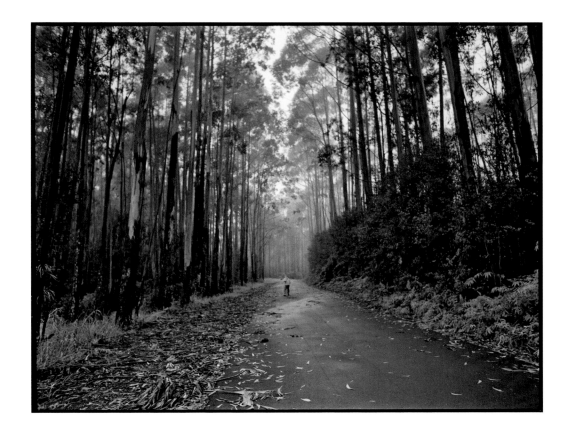

EUCALYPTUS FOREST ABOVE WAILEA

BIG ISLAND, HAWAII

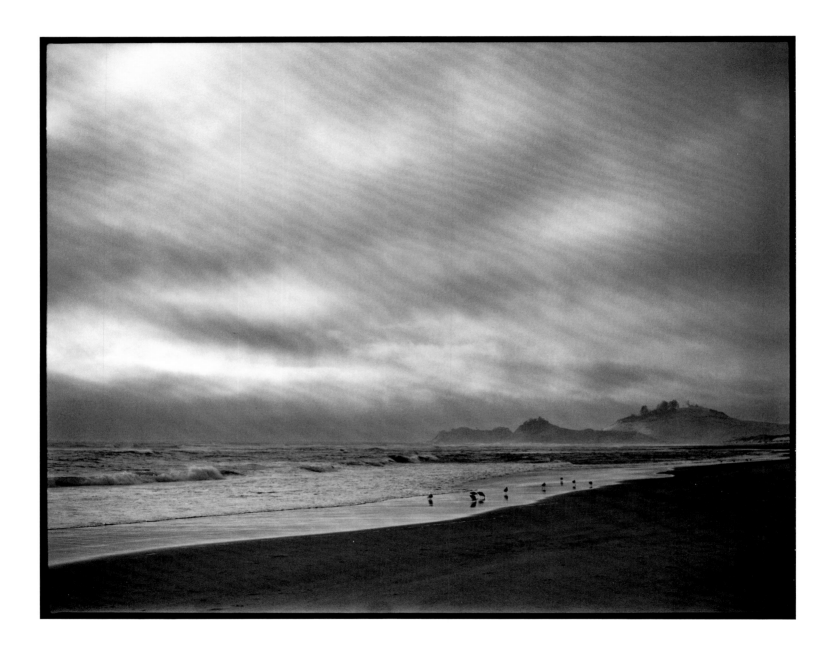

SEA AND SAND

OREGON COAST

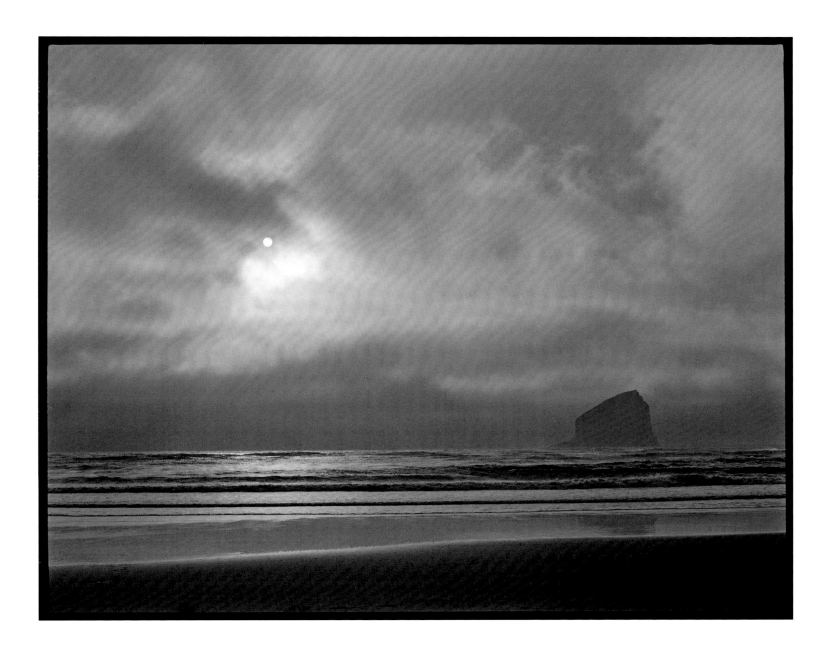

HAYSTACK ROCK

OREGON COAST

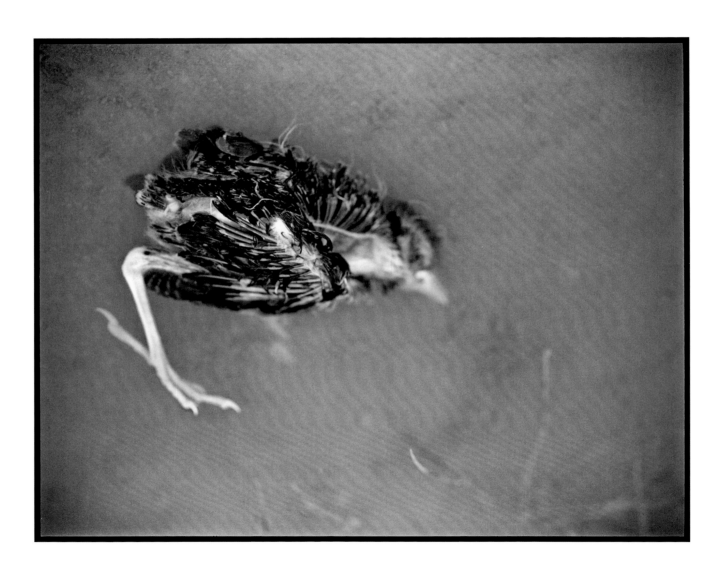

DEAD BIRD

BADLANDS, SOUTH DAKOTA

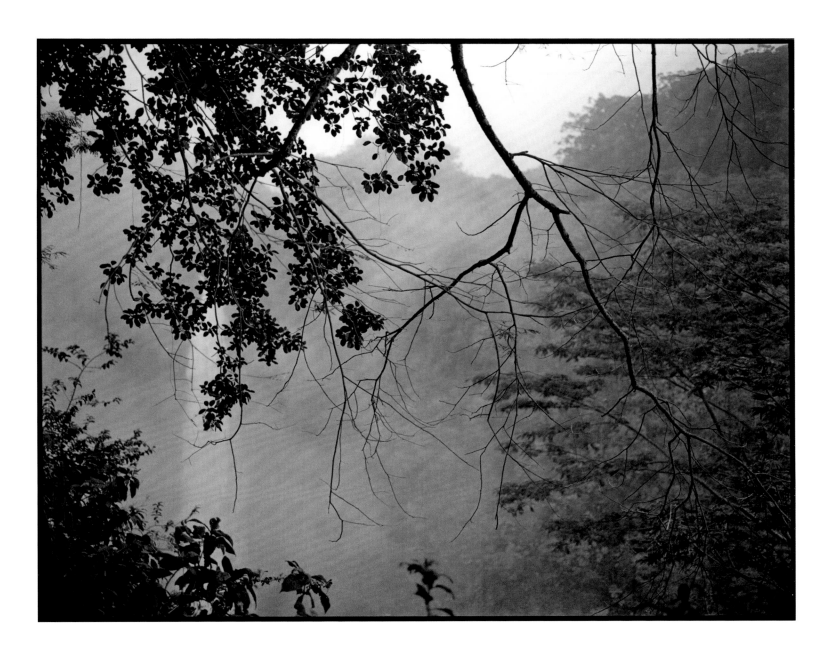

TREES AND MIST

AKAKA FALLS, BIG ISLAND, HAWAII

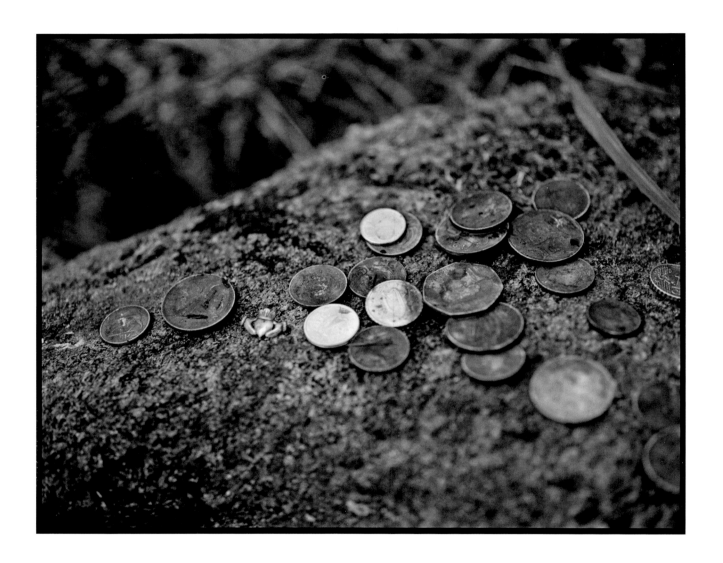

OFFERINGS AT SACRED WELL

CONNEMARA, IRELAND

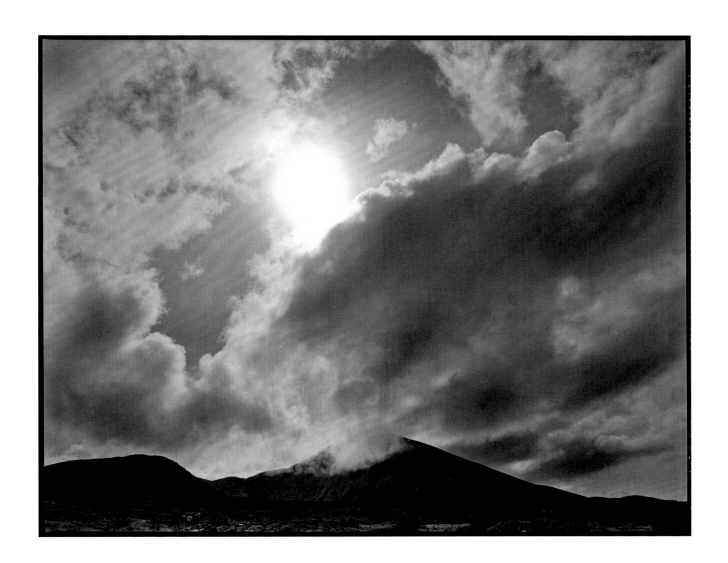

SKY OVER CROUGH PATRICK

IRELAND

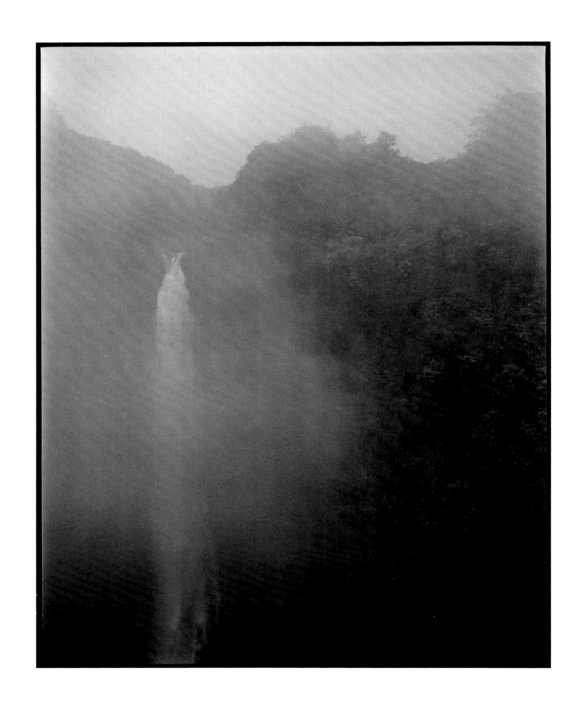

FOG AND MIST

AKAKA FALLS, BIG ISLAND, HAWAII

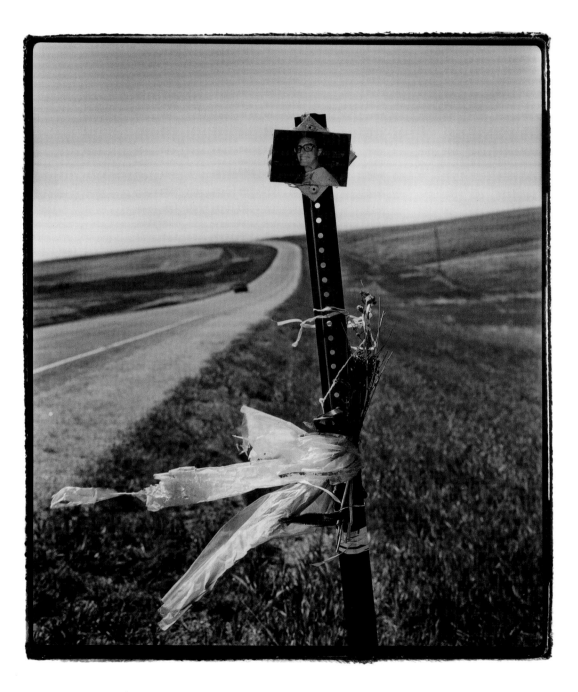

ROADSIDE MEMORIAL

WAMBLEE, SOUTH DAKOTA

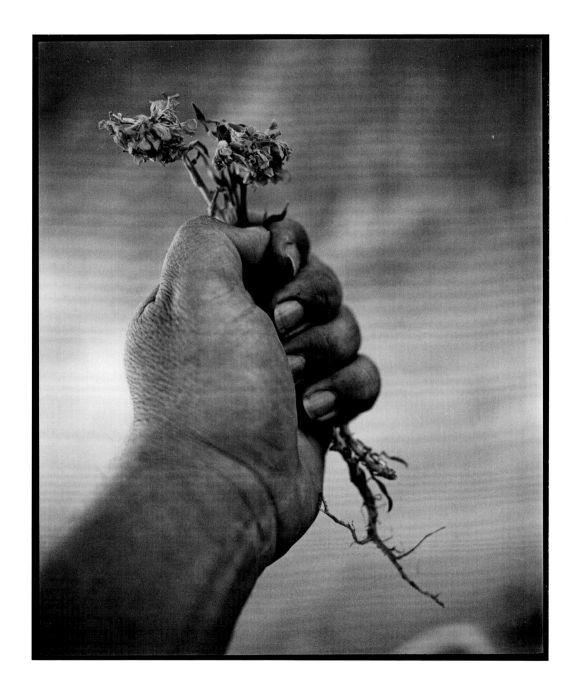

SELF-PORTRAIT AS DEAD FLOWERS

BADLANDS, SOUTH DAKOTA

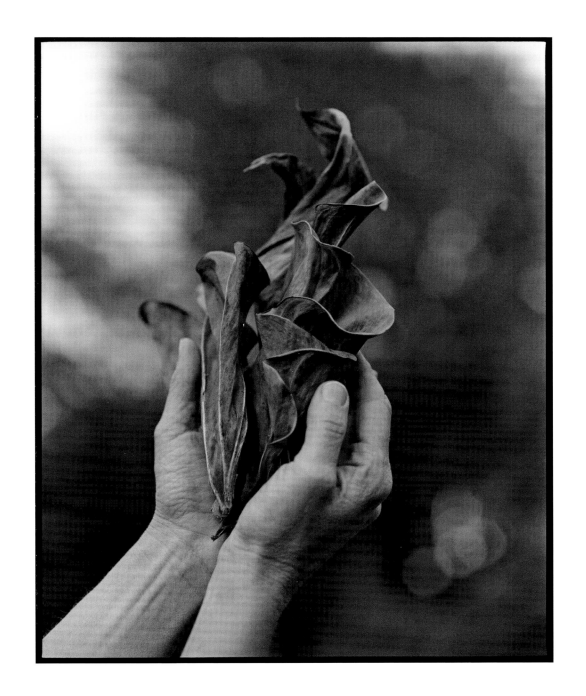

DRIED LEAF IN FRANCO'S HANDS

HILO, HAWAII

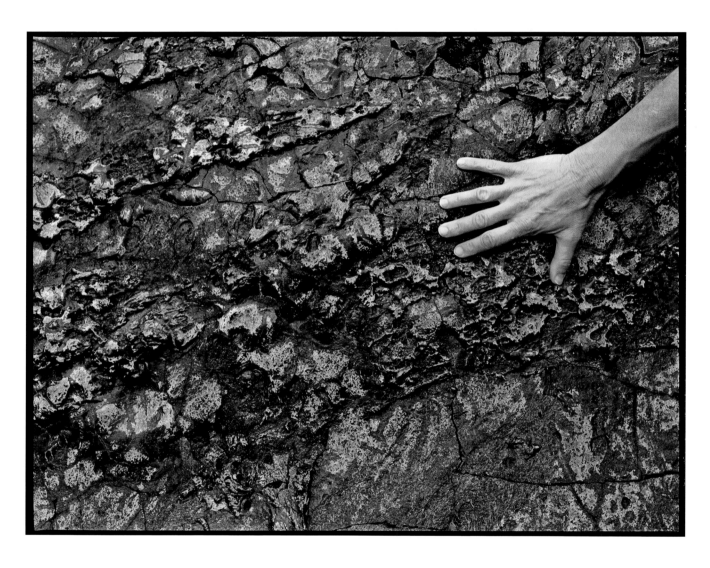

FRANCO'S HAND ON LAVA ROCK

KILUEA, BIG ISLAND, HAWAII

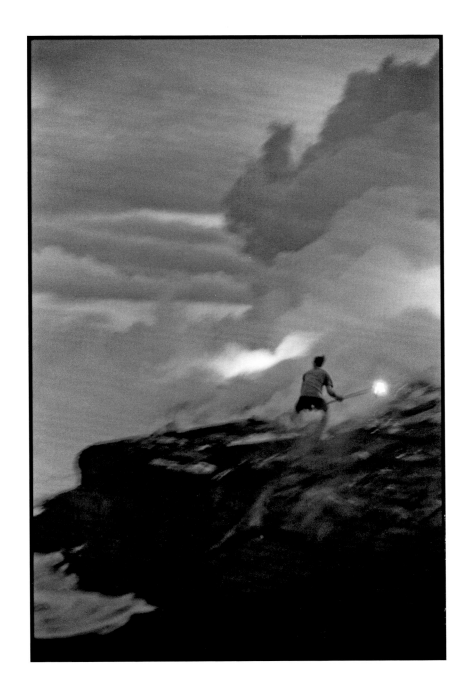

MAN PICKING UP MOLTEN LAVA WITH WOODEN STICK

KILAUEA, BIG ISLAND, HAWAII

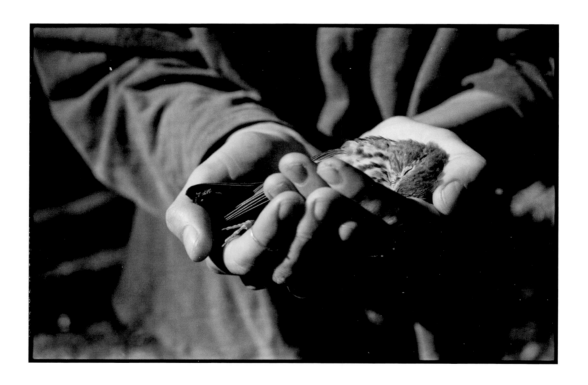

KRISTA HOLDING DEAD BIRD

UPPER PENINSULA, MICHIGAN

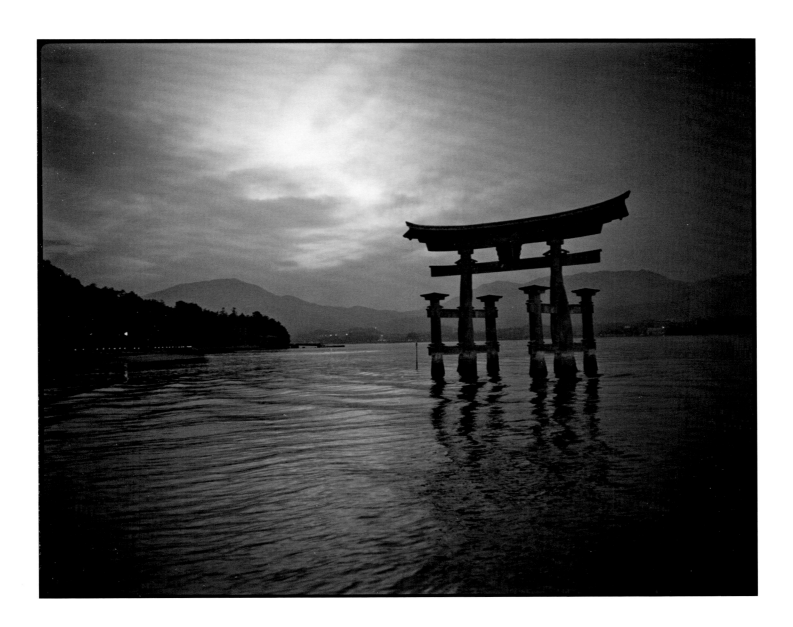

TORII GATE

MIYA JIMA, JAPAN

We have not ceased from exploration

and the end of all our exploring

will be to arrive where we started

and know the place

for the first time.

T.S. ELIOT

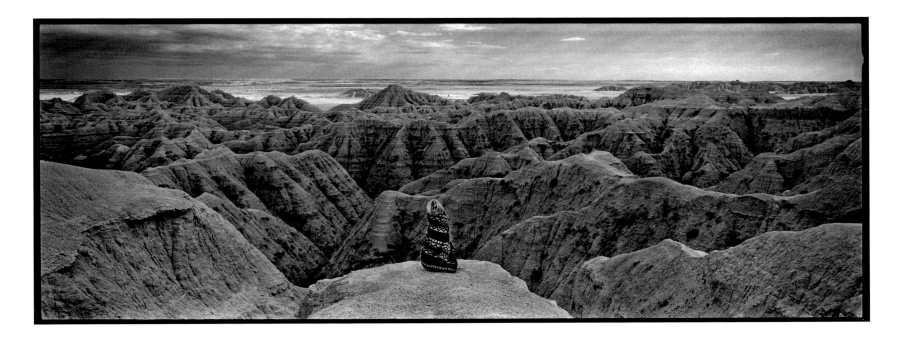

VANESSA OVERLOOKING BADLANDS
SOUTH DAKOTA

For some people, sacred is a place of religion, a church, monastery, temple or cathedral. For many others sacredness can exist in their connection to the land. These are specific places, windows in time, that are integral to our experience of life. Throughout time many indigenous peoples have marked their histories with stories of different places that were sacred to them. As a Native American I grew up with sacredness in much of the world around me, it was part of everyday life. Douglas Beasley's work has brought that sense of sacredness to life. As we view his photographs we are reminded of how such places make us feel. Seeing each image is to evoke the feelings held by such places. It allows me to experience memories and emotions that touch me deeply.

There are places that some feel are powerful, where one can go and be close to creation, to be held by the eternal. These places existed long before mankind and as we gain the ability to search for and explore those places we have been able to use these sites to restore and replenish ourselves. As you enjoy the works of Doug's passion, be reminded of his ability to hold a moment in time and the sacredness of that moment.

ANSEL WOODENKNIFE
Lakota

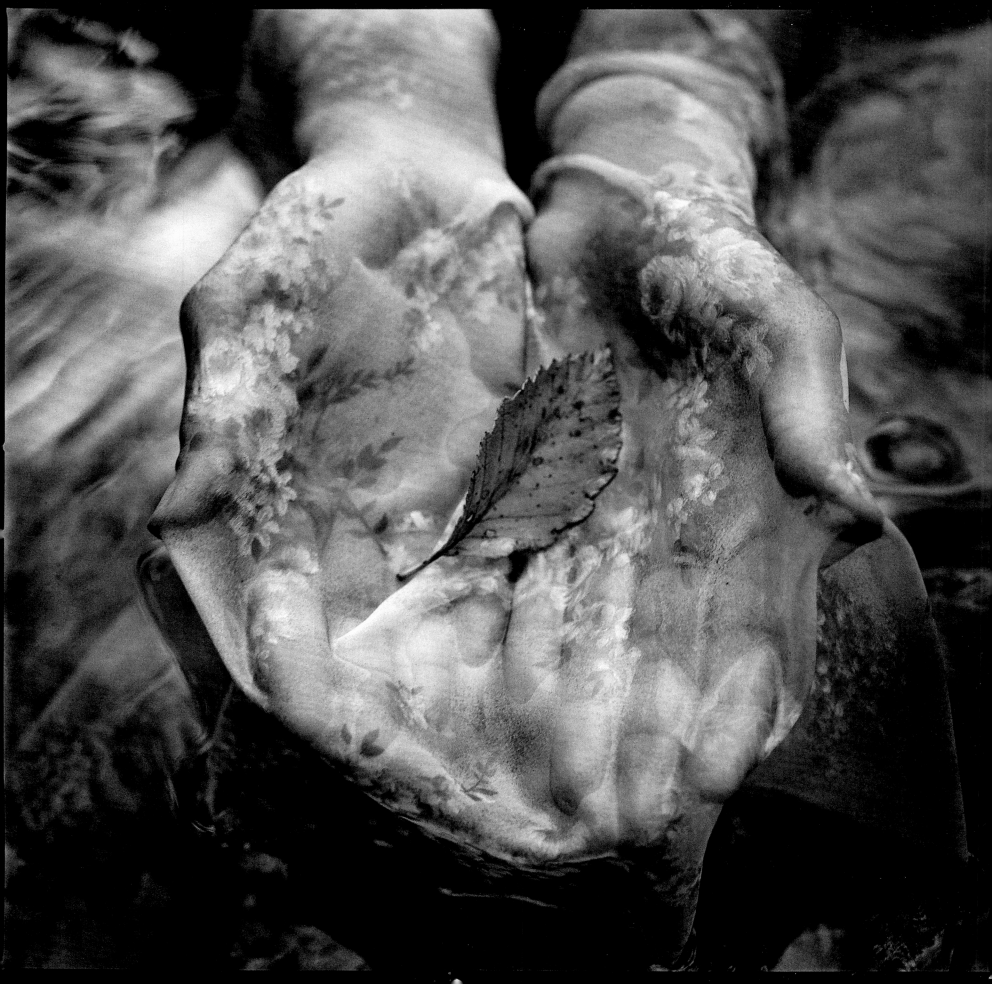

GRATITUDE

Thank you to Krista Matison for her beautiful, thoughtful design and enduring friendship, Janell Vircks, producer extraordinaire, for getting the ball rolling, Erica Abshez, my former Studio Manager, for multitasking and staying on top of many things, Ansel Woodenknife for sharing his vast knowledge and love of the Badlands, Franco Salmoiraghi, my spiritual/artistic brother from another mother, Daniel Kantor for his visual branding guidance and critical eye for detail, Clelia Belgrado, of Vision Quest Contemporary Photography in Genoa, Italy for her friendship and encouragement, Bill Olszewski for copy editing and moral support, Rick Haring for color work and expertise, interns Kelly Lyall and Kayla Peterson for digital support, Kumara for being the best daughter and my students and clients for sustaining my life of travel, adventure and artistic inquiry.

FULL PAGE IMAGES

Cover: SWEATLODGE AT SACRED PIPESTONE QUARRIES PIPESTONE. MINNESOTA

Plate 1: KUCHO ENDING SHAMAN'S CEREMONY WITH COCOA LEAVES MACHU PICCHU. PERU

Plate 2: SELF-PORTRAIT AS MOON BADLANDS. SOUTH DAKOTA

Plate 3: BULL AT FESTIVAL OLLETAMBO. PERU

Plate 4: MARIA PERFORMING SHAMAN'S CEREMONY PERU

Plate 5: LAKE SUPERIOR NEAR GRAND MARAIS. MINNESOTA – MADE WITH PLASTIC TOY CAMERA

Plate 6: CANDLES FOR MAXIMON SAN ANDREAS DE IXTAPA. GUATEMALA

Plate 7: HANDS HOLDING LEAF BREITENBUSH HOT SPRINGS. OREGON

TECHNICAL

Many of the images in this book were made with a 4x5" Ikeda, which is a Japanese cherry-wood, folding view camera. The film is 4x5" Type 55 Polaroid, which gives both a positive as well as a negative. The negative is fixed, washed and then digitally drum-scanned. Other images were made with both Hasselblad and Pentax medium-format cameras using 120mm Kodak Tri-X film. Panoramic images were made with a Hasselblad Xpan camera with 35mm Kodak Tri-X film. All film was processed by Rich Silha of Silha B&W in Minneapolis, Minnesota. The 4x5 Polaroid negatives were drum scanned by various pro labs and the digital scans of 120mm negatives were made by Erica Abshez in my studio on an Epson scanner. All images are used full-frame, no cropping of any images has been made, except the panoramic of Highway and Rainstorm, so it better fits the page.

All images available for purchase as prints or may be licensed for appropriate commercial usage. Contact Douglas Beasley directly.

ISBN 5 Continents Edition: 978-88-7439-600-9

CONTACT

Douglas Beasley Photography
2370 Hendon Avenue
Saint Paul, Minnesota 55108
USA
651-644-1400 telephone
651-644-2122 fax

e mail: info@douglasbeasley.com
website: www.douglasbeasley.com
photo workshops: www.VQphoto.com